IMAGES
*of America*

# FORGOTTEN
# SIOUX FALLS

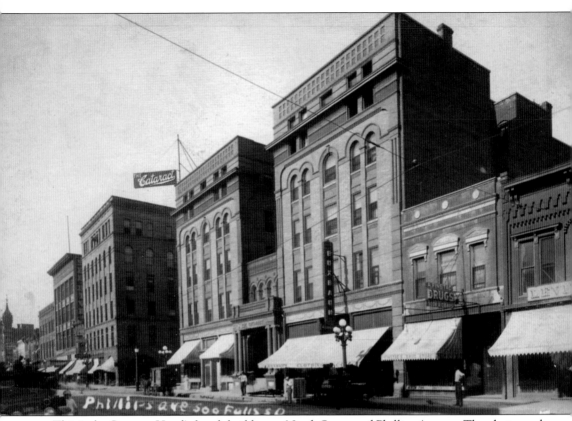

This is the Cataract Hotel's fourth building at Ninth Street and Phillips Avenue. The photograph was taken in the early 1900s and there is a good variety of transportation methods represented here. The Sioux Falls Traction System's trolleys rumbled through the major thoroughfares, but they shared the road with horses and the newfangled automobiles, which would eventually win out. Across Ninth Street and up the block a little, one can see the Minnehaha building with its distinctive arched entryway, the Bee Hive, which would eventually become Montgomery Ward, and the intricate clock tower of the old Masonic Temple.

ON THE COVER: The cover image shows Eleventh Street and Phillips Avenue looking north in the 1920s. To the left is the Carpenter Hotel and the clock tower of the old Masonic Temple, which was torn down in 1929. The tangle of cables and wires above the streets was used for the Sioux Falls Traction System's trolleys. (Author's collection.)

IMAGES
*of America*

# FORGOTTEN
# SIOUX FALLS

Eric Renshaw

ARCADIA
PUBLISHING

Published by Arcadia Publishing
Charleston, South Carolina

Printed in the United States of America

Library of Congress control number: 2012938401

For all general information, please contact Arcadia Publishing:
Telephone 843-853-2070
Fax 843-853-0044
E-mail sales@arcadiapublishing.com
For customer service and orders:
Toll-Free 1-888-313-2665

Visit us on the Internet at www.arcadiapublishing.com

*I dedicate this book to my mother. I love you mom.
I could not do any of this without the support of my wife, Mel,
and my two children, Griffin and Norah. When I go out to take
pictures of the city or go digging through dusty tomes of forgotten
history, I always feel an urge to come back to the present and
be surrounded by the ones whom I love and who love me.*

# CONTENTS

# ACKNOWLEDGMENTS

This book could not have been written without the help of all the people who have provided their input, photographs, and kind words over the years: Roger Blair, Jill Callison, Dave Fetters, Stephanie Gongopoulos, Mark Helberg, Tom Johnson, Laurie Langland, Doug Lund, Don Noordsy, Jerry Parr, Bill Pay, Kent and Bruce Scribner, Stacy Newcomb Weiland, and the countless others I've met through GreetingsFromSiouxFalls.com, who have made my understanding of this fair city deeper and richer than I could have imagined. Thanks to the gang down at MacDoctors for pretending to be interested when I ramble on about the past. Larry Lamb, Dan Meinke, Colleen Iverson, George Gongopoulos, Garret Fritzemeier, and Ryan Strampe. My thanks to Jeff Ruetsche at Arcadia for discovering my little ol' website and seeing potential for putting it into print.

# INTRODUCTION

I moved to Sioux Falls from Yankton on July 4, 1985. For most of my life up to that point, I had spent no more than a couple of years in any of the cities in which I had lived. When I found myself in Sioux Falls for more than a few years, some roots started taking hold and some of Sioux Falls's history started seeping in and piquing my interest. Woodrow Wilson has been in Sioux Falls, and Teddy Roosevelt; who knows, maybe my feet have fallen on the same path as these historical figures.

History is all around us if we can be bothered to look, and often the truth can be discovered with a little research and not too many leaps of understanding. I would like to offer a taste of Sioux Falls's past in this book, to offer a bit of history to serve as a jumping-off point if your interest is piqued. You may see some images you have seen before, but I also hope I can show you some you have not seen or at least offer a tidbit of information that is new to you.

I would love it if someone who read this book became passionate about preserving some piece of Sioux Falls history. Too much has been lost, and there is more left to lose if we are not careful. Every historical building that is torn down represents an erosion of Sioux Falls's rich past. While it does not make sense to keep every structure that has ever existed, we need to be mindful of what we could lose. The old courthouse was very nearly lost to us and replaced with a parking lot. More recently, the coliseum was on schedule to be razed despite its rich history. There was great resistance to keeping the old Washington High School and turning it into the Washington Pavilion. I am glad it was saved, not just because of the history, but because the pavilion gives the city much more than any other location could. It increases civic pride and provides education and culture that you cannot get from the Big Boy Toy Show.

If I have succeeded and you are interested in looking into the history of this great city, there are a good number of resources that I can suggest. Check out Rick Odland's Images of America: *Sioux Falls*. Arcadia publishes it in the same series as the book you now peruse, and there is hopefully not too much overlap between the two. The go-to book for deeper history reading is *Sioux Falls, South Dakota: A Pictorial History*, by Gary D. Olson and Erik L. Olson. This can be had from the Center For Western Studies on the Augustana College campus (the old Lutheran normal school). *South Dakota* magazine is a great periodical with plenty to tell about the state. You could also head down to the main library downtown and go spelunking through the more than 100 years of microfilm they keep handy. It is best to make an appointment, though their machines are rarely all full. The Siouxland Library's website has a wealth of databases as well. If you have a library card, you can access the Sanborn Fire Maps, which show the city's layout and the location of buildings from 1883 to 1950.

Once you are on your way to looking more deeply into this history, keep with you a sense of skepticism. There are contradictions everywhere in history. If you see a historical marker that says John Dillinger was in town to make a withdrawal, do not assume it is fact. Absorb the information and make conclusions based on all the facts and misinformation you can find. The truth is in

there somewhere. Pictures from the past rarely lie. Photoshop really did not come into its own until after the computer was created.

Please have fun with history. There is some serious stuff back there, but there is joy and life and glee to be found too. Start digging your fingers into the muck of the past and you may find some interesting stories sifting to the surface. I have heard loads of wonderful memories of the past from people all over the world. People remember where they were when the Harold's building downtown burned down, what they were eating at Shriver's cafe when Apollo 13 arrived safely back on Earth, and that John F. Kennedy waved at them when he came to campaign in town. These little tidbits make history more palpable, more real.

Too much has been forgotten, so let us all do our best to remind one another of the amazing things this city has offered to its residents. Sioux Falls is a living, breathing entity and its streets run with the people that are its lifeblood. Share the images found within these pages with someone who might be interested (but don't loan them your copy, make them buy their own). Share your own memories with others. If you remember the Barrell or the Cottage as a place you used to hang out, tell the people in your life the interesting stories you have about these places. If you remember seeing *Gone With the Wind* at the State Theatre, or *Back to the Future* or *Ferris Bueller's Day Off* at the Hollywood on a second run, tell someone. Share the photographs you have in your albums. If you have amazing photographs of forgotten Sioux Falls, share them so that we may all become richer for your offering.

Photographs are great, but stories will make your images really pop, so do not skimp on the things you remember. Did you ride the escalator at Penney's 15 times on a dare before the manager threw you out? Do you remember riding the steam engine around Joyland Park when you were just a tyke? Did Captain 11 pick you to flip a switch on his amazing control panel? Do not keep it to yourself, share with everyone who will listen. Maybe they will share with you, too. "None of us is as smart as all of us" is a phrase a former employer used in their culture; there is wisdom in that phrase that I took with me when I left.

# One

# GONE BUT NOT
# FORGOTTEN

As is the norm for any city, the old must make way for the new. Old, disused buildings must be removed to make way for fresh spaces to work, shop, and conduct the business of government. There is a long list of buildings that have been removed from the Sioux Falls skyline; some of them are easily forgotten and some of them leave a scar that never heals. This chapter brings to light some of these missing buildings, which were once important to the city but are now gone.

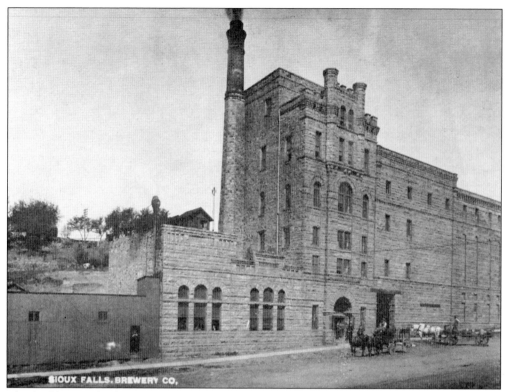

This building was built in 1904 at 801 North Main Avenue after the Sioux Falls Brewing Company outgrew its previous home. It was run by G.A. Knott and local merchant C.K. Howard. By 1885, they were cranking out 100,000 barrels of beer a year, so a new facility was a must.

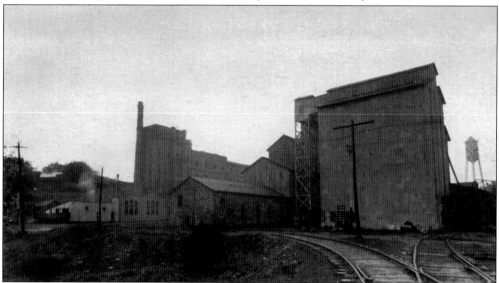

The Sioux Falls Malting Company building (right) was built before the new brewery. This facility produced the barley and hops for the brewery as well as for other brewers. South Dakota adopted prohibition before the rest of the country, from 1890 to 1896 and again from 1917 to 1918. The company survived during this time as it was still able to produce and sell its wares to other states.

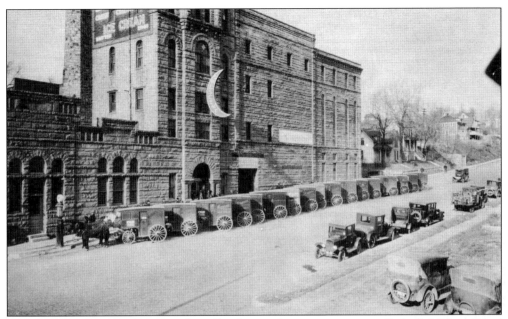

In 1919, the 18th Amendment made it illegal to produce, transport, or sell alcohol. That meant curtains for the Sioux Falls Brewing Company. The Crescent Creamery moved into the old building, attaching a huge crescent moon to the front of the building to make it their own. They delivered milk and dairy products to Sioux Falls and surrounding areas, using horses into the 1950s.

Crescent Creamery was acquired by Foremost Dairy in 1953. At the time, they were able to produce 7,000 gallons of milk a day from the old brewery. On October 10, 1987, the old Sioux Falls Brewery building burned down, leaving local hot dog vendor Clyde Twiggs homeless. The investigation revealed that the cause of the fire was arson.

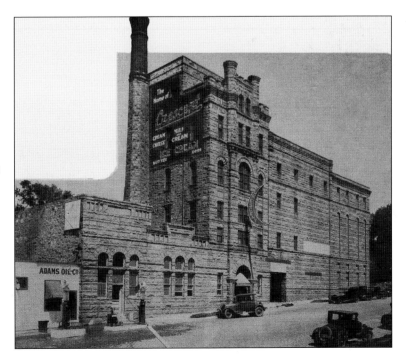

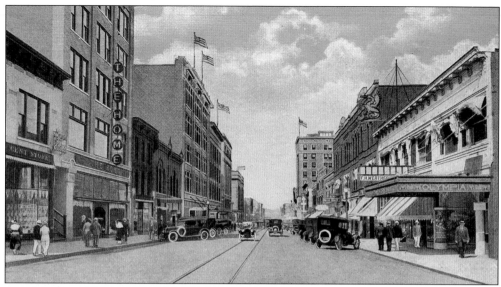

On June 30, 1909, the Olympia Theatre opened as the most complete and attractive motion picture house in the state. Established in the brand new Carswell Block on the east side of Phillips Avenue near Tenth Street, the house seated 250 people upon opening. Later, the theater was renovated and the seating was expanded to 387. The building would later serve as the Royal Theater and Time Theater.

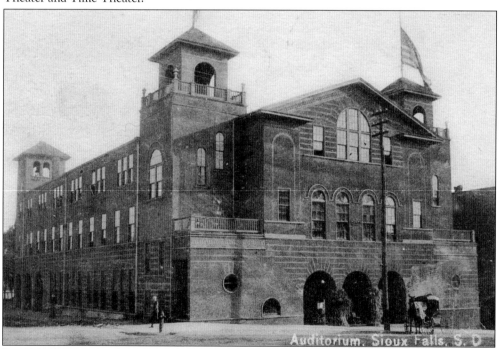

In 1899, the Sioux Falls Business Men's League talked the National Buttermaker's Association into holding their convention in Sioux Falls. With the cream of America's dairy producers heading to town, Sioux Falls needed a venue to contain them and their creamy merriment. In six months, they constructed this beautiful building at Ninth Street and Dakota Avenue, where city hall now stands.

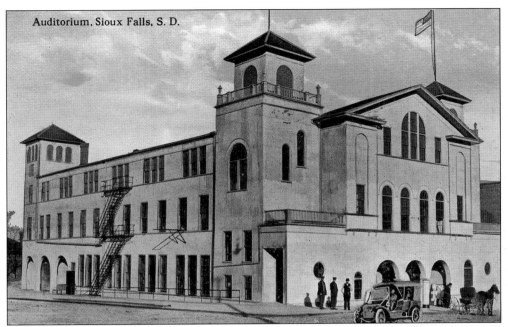

Auditorium, Sioux Falls, S. D.

This building's architect was Wallace Dow, and though not as intricate as the courthouse or post office, it was still an impressive presence in downtown Sioux Falls. The building was ready in time for the Buttermakers, though it was not completely finished. By 1900, it was used to house the city's fire equipment until a dedicated fire station was built.

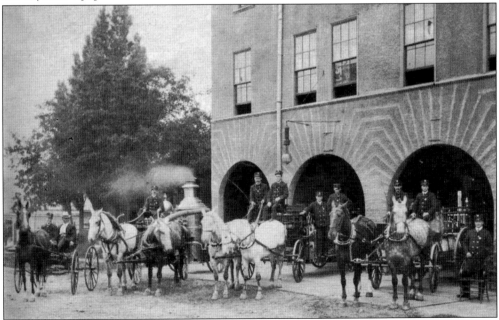

The bell that today stands before the central fire station once rang from the top of the city auditorium. The fire department worked out of the auditorium until 1912, when the central fire station was built at Ninth Street and Minnesota Avenue. The city auditorium and its neighbor, Germania Hall (Columbia Hall after World War I), were razed to make way for the new city hall in 1936. (Courtesy Mark Helberg.)

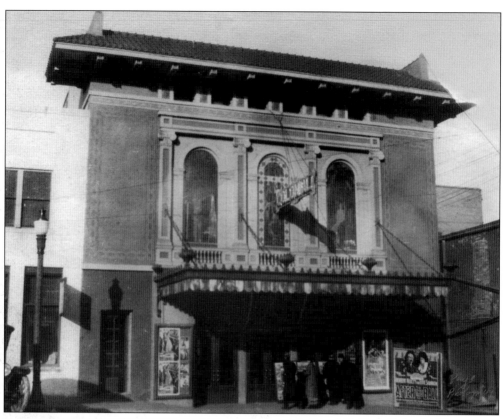

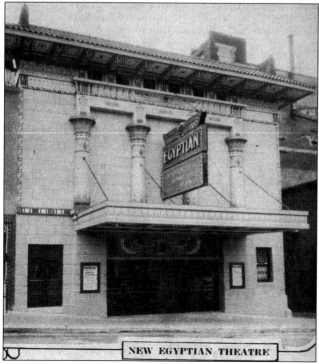

NEW EGYPTIAN THEATRE

A.K. Pay's Colonial Theater opened on January 30, 1915. The building was designed by Sioux Falls native Henry J. Schwarz in 1913 as his University of Pennsylvania senior project. The theater closed in 1926 and reopened later that same year as the Egyptian Theater. (Courtesy Bill Pay.)

Notice the differences between the Colonial and the Egyptian, pictured here. Ionic columns with scrolled tops were replaced with Egyptian-inspired columns. Egypt was on the mind and in the imagination of the moviegoer after Howard Carter discovered King Tutankhamun's tomb in 1922, making Egyptian Revival architecture the order of the day.

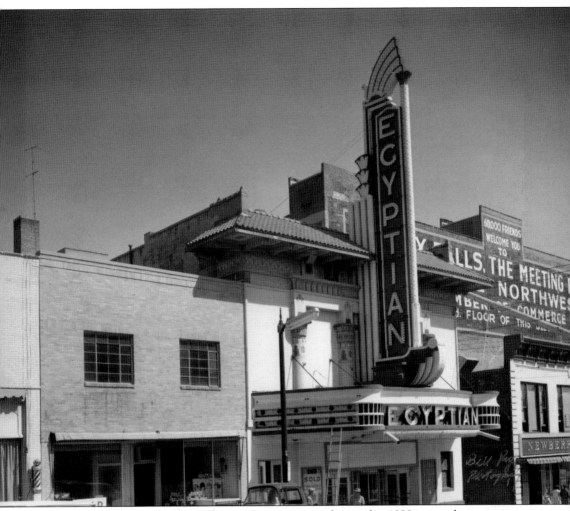

The Egyptian is seen here in 1962. The new Deco marquee designed in 1938 positively overpowers the building behind it. For sure, it is an eye-catcher, but the attractive details from the earlier photographs now seem an afterthought. The Egyptian Theater showed its last film in 1961—Billy Wilder's *The Apartment*. By 1963, it was razed and replaced by Egyptian Parking. (Courtesy Bill Pay.)

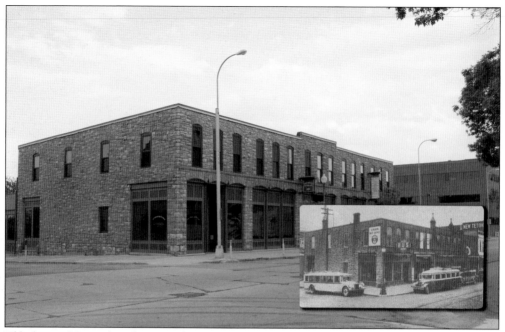

The former Union bus depot at the southeast corner of Seventh Street and Phillips Avenue was not the perfect place to dock several big buses, as it was in the heart of the business section of Sioux Falls. A new depot was decided on a few blocks away, on Seventh Street and Dakota Avenue, to take some of the pressure off downtown traffic.

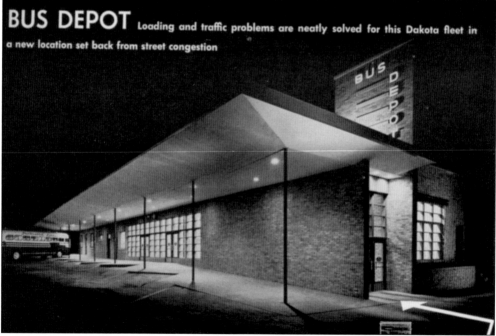

Local architects Perkins & McWayne designed this new depot in 1947. It had 32 scheduled trips every day, transporting 650 passengers in a 24-hour period. The angled parking spaces helped to accommodate a greater number of buses at a time, making for a very efficient use of space.

The lunch counter at the depot had 24 seats to handle a good number of travelers waiting for the next bus, or downtown shoppers and business people looking for lunch. Notice the ramp to the right for wheelchair access.

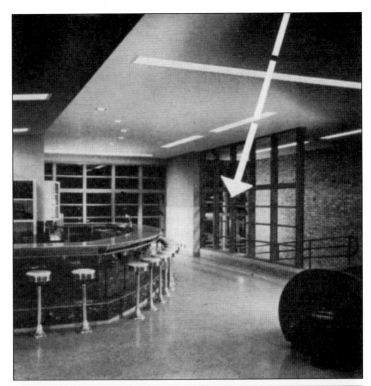

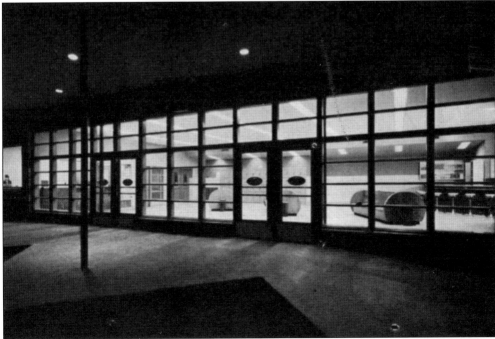

This charming night view suggests an alluring vision to the itchy-footed traveler. The depot was torn down in 2005 owing to much lower volumes of bus travel and a need for parking space in the area. While it is not a significant loss to Sioux Falls, it is strangely easy to forget its 57-year presence in our community.

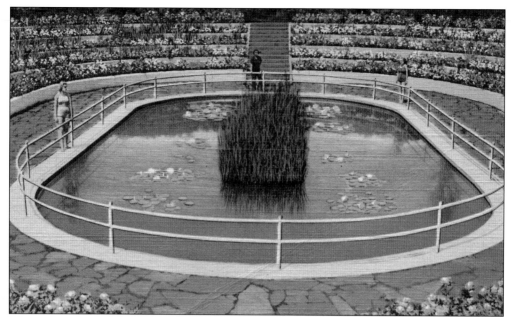

The sunken garden at Nelson Park, sometimes called the Drake Springs Sunken Gardens, was a pleasant attraction for citizens of Sioux Falls. Located right next to Drake Springs pool, the sunken garden also took advantage of the natural spring water that Colonel Drake discovered. It is rare to see the sunken garden without swimsuit-wearing admirers enjoying the flowers and water plants.

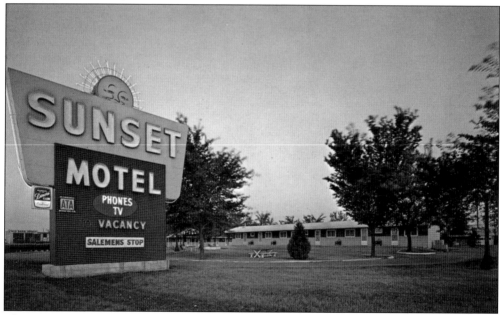

The Sunset Motel was a classic mom-and-pop motel once located at Twelfth Street and Marion Road. This big sign stood by the road for years before they hoisted it atop a set of I-beams for better visibility and the widening of Twelfth Street. The sun peeking over the sign is the same logo used by the local Sunshine foods stores for years. The Sunset Motel left us in 2006.

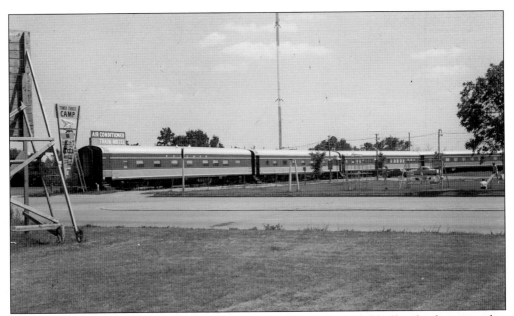

The Sioux Chief Traintel opened for business around 1963, the brainchild of local radio personality Verle Thompson. Thompson purchased five Pullman sleeping cars formerly used on a run from Chicago to Oakland, California. These cars were placed on a stretch of disconnected track near the intersection of Highway 16 and Interstate 29 and opened as the world's first train motel.

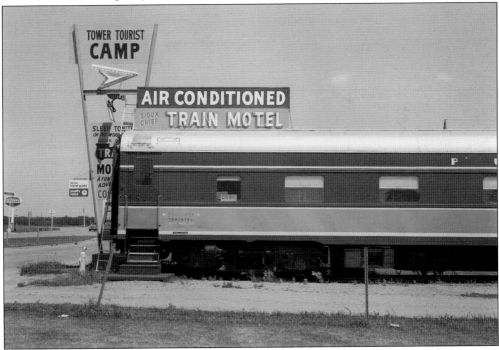

The Pullman Cars provided 38 units of train-like luxury. Each of the cars was named for a different area in San Francisco: Civic Center, Hunter's Point, Montgomery Street, Rincon Hill, and Rose Bowl. All of these cars were fashioned into motel rooms except the Montgomery Street, which was originally a coach car (seats only). The seats were removed and it was used as the Traintel office.

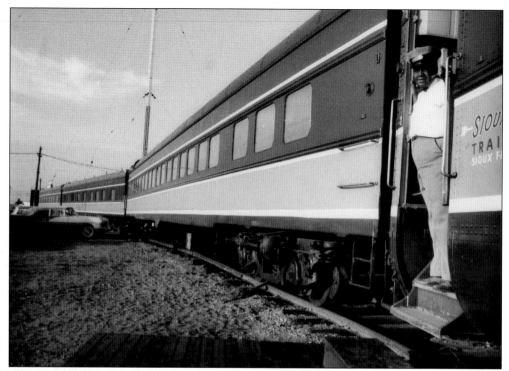

Guests of the Traintel enjoyed air-conditioned comfort and recordings of railroad sounds, including that familiar lonesome whistle, to help with the illusion of rail travel. Porter George Wells lent even more authenticity to things with his uniformed service.

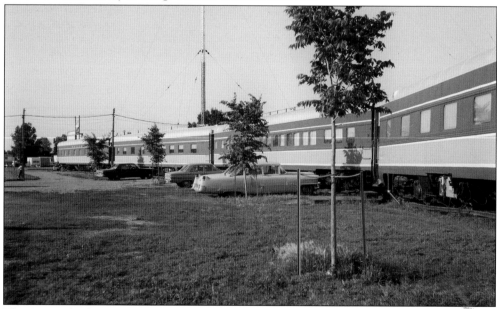

The Sioux Chief Traintel hit the rails again in May 1990. The cars were sold to private parties and still exist to this day, some restored and some waiting to be restored. These cars had history before they got to Sioux Falls, stopped for a short time to become a part of Sioux Falls history, and then rolled on down the line.

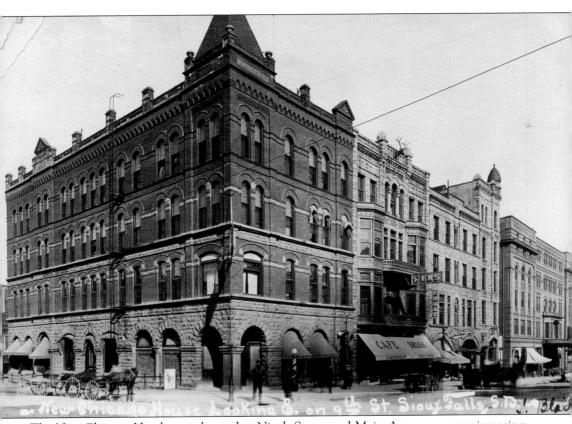

The New Chicago Hotel, once located at Ninth Street and Main Avenue, was an imposing structure but played second fiddle to the finer hotels down on Phillips Avenue, like the Cataract at the far right. The New Chicago once stood just a block from the Cataract. It later became the Lincoln Hotel and was razed in 1973, along with the other majestic castles on the block.

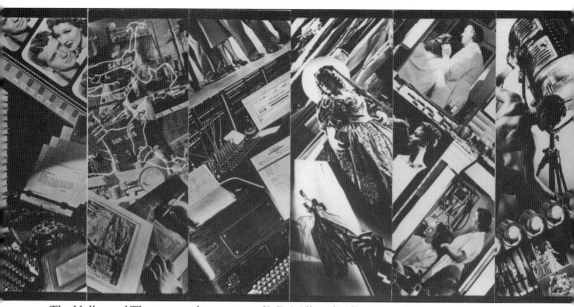

The Hollywood Theatre was the creation of L.D. Miller of Miller Funeral Home and Joe L. Floyd, the manager of the Granada Theatre. Miller owned the land once occupied by the Riewert Hotel—also known as the Commercial House and the New Teton—and footed the bill for the construction of the Hollywood Theatre. Floyd's Welworth Theatres paid for the theatrical equipment and decorations. This famous pictorial mural was photographed for the theater by Hollywood still-photographer

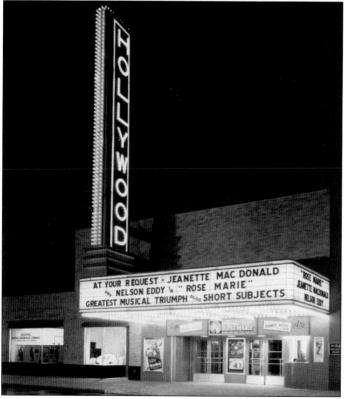

The Hollywood Theatre was designed by architect Harold Spitznagel. The understated facade was overpowered by the 36-foot-high sign, but the finer details were within. The bulbs on the front of the sign would chase in a cascading pattern from top to bottom. Green neon tubes bordered the letters and there were hidden neon tubes indirectly lighting the base of the sign. (Courtesy Roger Blair.)

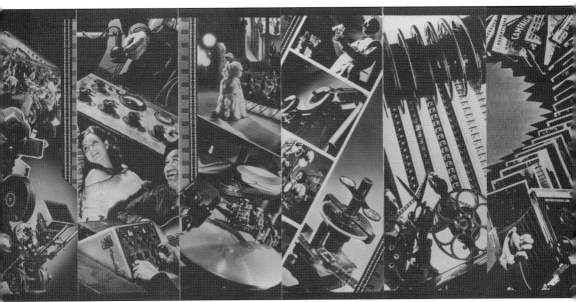

Whitey Schaefer. Schaefer used Hollywood actors and behind-the-scenes technicians to depict 12 phases of movie production, from script writing to projection. He then sent the pictures to Chicago, where photographer Kenneth Hedrich blew the images up to 10 feet tall, making the whole series 45 feet wide if viewed in a straight line. (Courtesy Roger Blair.)

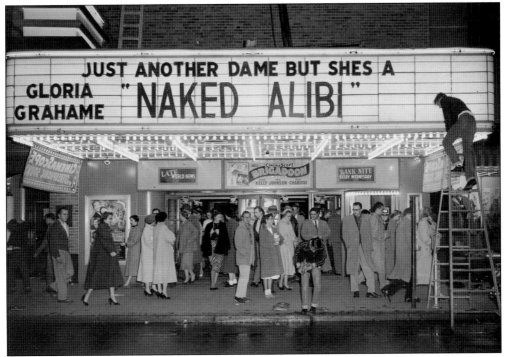

The guests of the Hollywood would come through the front doors to a vestibule designed to provide protection during inclement weather. The entire room was coated with a new type of flexible rubber. From the vestibule, the customer would enter the two-story lobby. It was in this room that guests first laid eyes on the amazing photograph mural. (Courtesy Midcontinent Media/Ken Mills.)

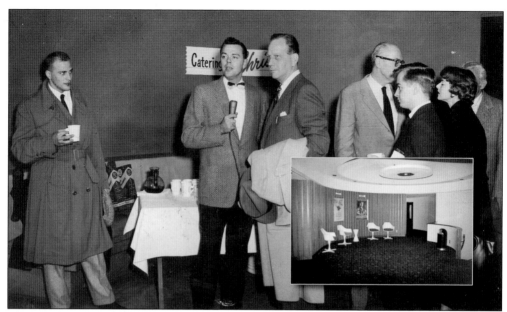

The mural images were covered with layers of paint in a 1950s lobby update. They once occupied the tall space above the concession stand but were completely hidden in a 1967 remodel. Though there was some talk of rescue, the mural itself was likely lost to the wrecking ball. From the lobby, guests of the Hollywood entered a circular foyer with a dramatically lit, round plaster ceiling, like an upside-down bowl. In the foyer, a curved staircase led down to the richly appointed lounge. Even in the end, the restrooms found down here were surprisingly modern and pleasant. The auditorium walls were designed with five apparently overlapping sections of wall on each side of the room, with indirect lighting hidden in the area of the overlap. There were originally 768 seats installed in the auditorium. During a 1967 remodel, rocking seats were installed to replace the originals, reducing the seating to 567. These rocking seats are still in use in the West Mall 7 theaters in auditoriums 3 and 6. (Courtesy Midcontinent Media/Ken Mills, inset courtesy Dave Fetters.)

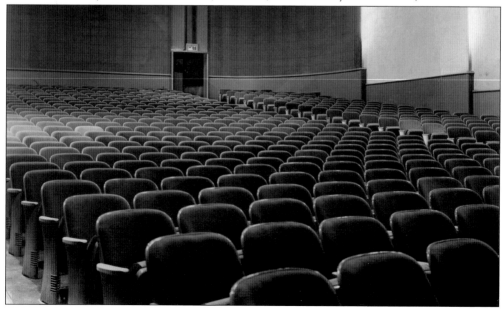

In later years, the single-screen theater gave way to the multiplex. Downtown theaters began to suffer and needed to resort to second-run showings, while the theaters in the malls got all the first-run fare. (Courtesy Dave Fetters.)

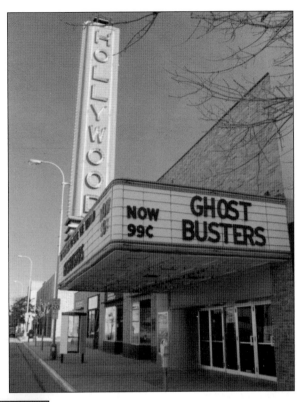

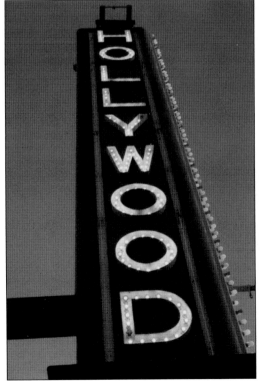

On September 27, 1987, the Hollywood Theatre showed its last film, *The Last Picture Show*, to KELO radio listeners. No tickets were available at the booth. The marquee of the Hollywood Theatre was dark until the building was demolished on February 13, 1990. It was replaced with a blacktop parking lot, which has so far not entertained as much as a single person. (Courtesy Dave Fetters.)

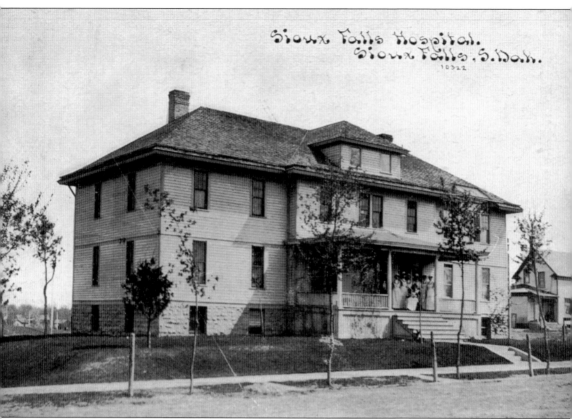

Sioux Falls Hospital, the first hospital in town, was built in 1901 at the corner of Nineteenth Street and Minnesota Avenue. Eventually, it would become Sioux Valley Hospital and remain so for 82 years. This building was moved to the hospital campus to become a nurse's dormitory. In 2007, Sioux Valley Hospital changed its name to Sanford Hospital to honor a $400 million donation by T. Denny Sanford.

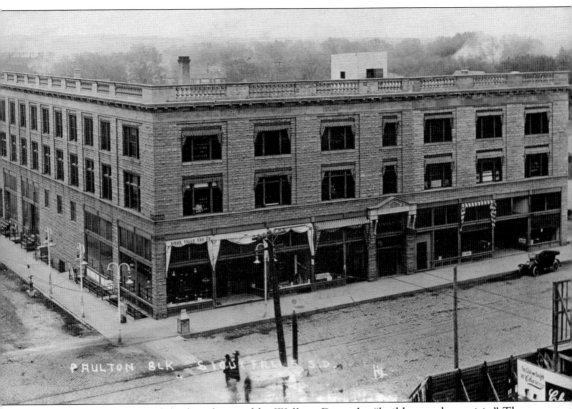

This building was one of the last designed by Wallace Dow, the "builder on the prairie." The Paulton Block was originally designed as a theater in 1905, but never got to light the footlights. It was instead filled with businesses and retail space. Sioux Falls Gas Company was selling lamps from its corner storefront at that time. The building was built in two sections, with the corner building up to the Phillips Street main entrance started in 1905. The addition to the south of the entrance was completed in 1910, a short time before Dow's death in 1911. Notice the electrical wires over the streets and the tracks running up Phillips Avenue for the trolleys. The Paulton Block burned down on May 25, 1991. The huge fire drew large crowds and ash could be found for miles around.

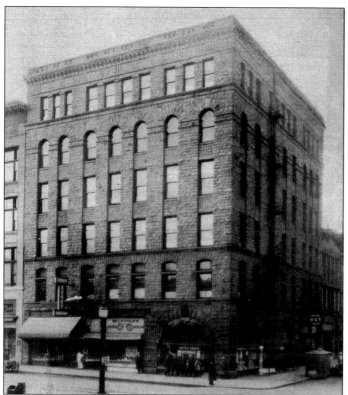

The Edmison-Jamison Building was built in 1890 and designed by architect Wallace Dow. Located at the southwest corner of Ninth Street and Phillips Avenue, its upper floors were occupied primarily with lawyers looking for quick access to the clients across the Street at the Cataract Hotel, who were hoping to take advantage of South Dakota's relaxed divorce laws.

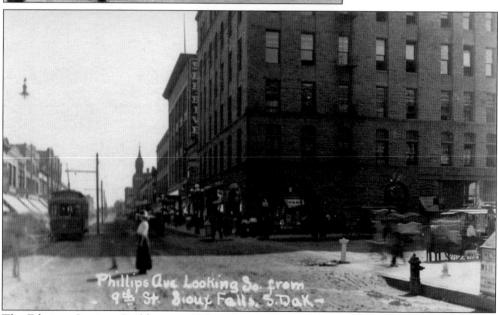

The Edmison-Jamison Building would later be renamed the Minnehaha Building and lose its top four floors in 1947 for fire safety reasons. It was given a traditional 1950s facelift in which the most distinctive and beautiful features remaining were covered with stone, giving it a more modern feel. This facade was later changed to a wood-clad rustic look when it housed Hubbards Kupboard in the 1970s.

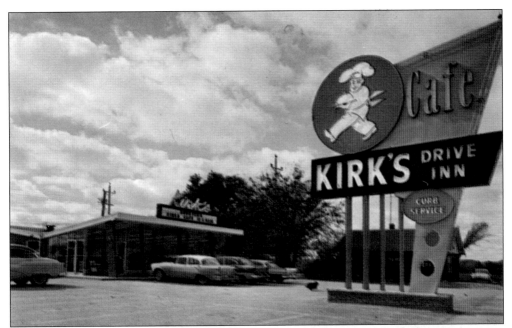

The Kirk brothers—Larry, George, Chris, and Ted—were already running a Kirk's Cafe downtown at the northeast corner of Tenth Street and Main Avenue when they opened Kirk's Drive Inn at the southeast corner of Twelfth Street and Kiwanis Avenue in 1955. They were looking for some insurance against the possible failure of their downtown venture, which held on until 1972. They also wanted to appeal to those who wanted the convenience of dining in their cars. Kirk's Drive Inn was open 24 hours a day and offered curb service from 11:00 a.m. to 2:00 a.m. The sign below was the last remnant of Kirk's that remained after it closed in 1989. Walgreens then built the store that currently occupies Kirk's old space. They have a drive-up for prescriptions, but they do not serve food.

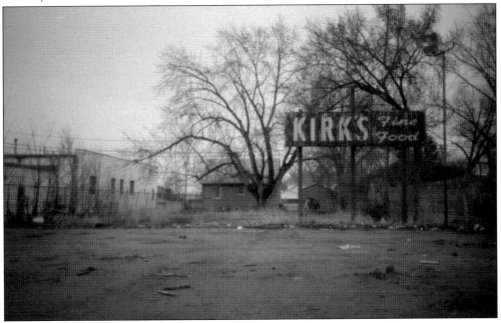

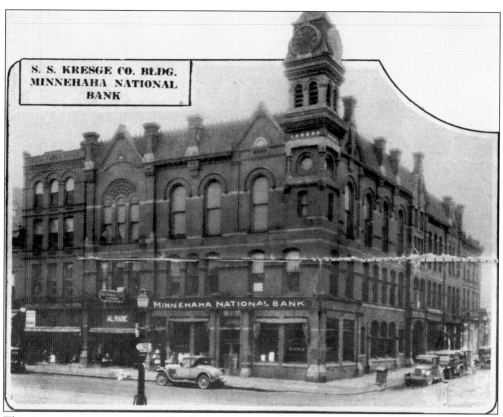

This imposing structure, at 201 South Phillips Avenue, was a fixture in Sioux Falls for 45 years. It was completed in 1884 as the first home for Minnehaha Lodge No. 5 of the Free Masons. The building, designed by Wallace Dow, was used by the Masons from 1884 to 1905, when their new lodge was built. From 1898 until 1929, Minnehaha National Bank (later renamed First National Bank) used the main floor.

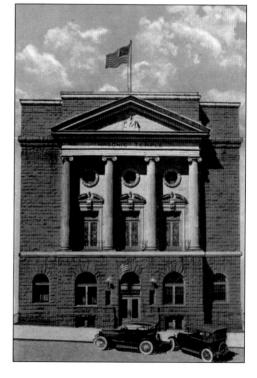

The grand beauty at right once stood at 210 West Tenth Street, just a block west of the Egyptian Theatre. On May 2, 1956, Sioux Falls's fire department was called to put out a blaze in the building. The damage was too great and the building was lost.

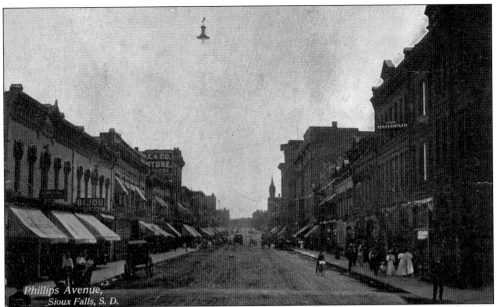

On December 25, 1916, the Strand Theatre opened to the public at the southeast corner of Eighth Street and Phillips Avenue. The Strand was the first of many names the theater went by. The gorgeous 1882 Van Eps block at left was removed, leaving its twin, the 1885 building, alone next to the theater for years to come. The Strand showed movies and had a stage for vaudeville performances. The first film, shown to Christmas day theatergoers, was *The Truant Soul*, a silent film about a doctor with a drug problem and the headstrong nurse who saved him and became his wife. This sort of fare was popular at the time, as popular opinion was rolling to a boil about alcohol and other substance abuse.

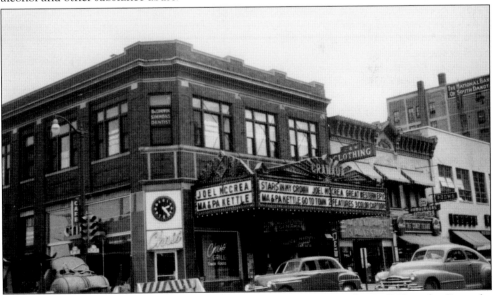

On September 8, 1929, the Strand Theatre closed, re-opening on October 1, 1929, as the Granada. The William Fox Movietone Follies of 1929 opened the show. It was touted as all singing, all dancing, all talking. It was 1929 and silent movies were old shoe. The Granada was Sioux Falls's "New Deluxe Talking Picture Theatre," according to the *Argus Leader*. (Courtesy Tom Johnson.)

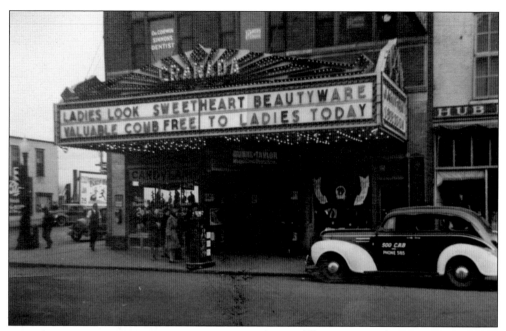

The interior architecture was designed to celebrate a Spanish influence, as suggested by the new name. Spain was an exotic getaway at the time, and those who could not afford to go there could still see it on the big screen, providing them with an escape. One could also come home with a valuable comb, as advertised on the marquee. (Courtesy Tom Johnson.)

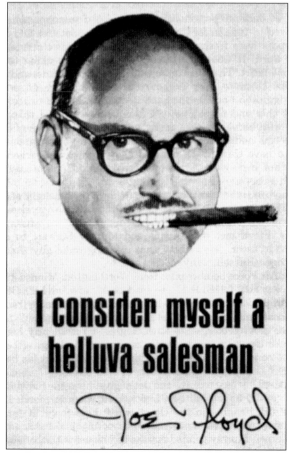

# I consider myself a helluva salesman

*Joe Floyd*

Eddie Ruben of Minneapolis bought the Granada from Benny Berger in the mid-1930s and assigned 19-year-old Joe Floyd (left, years later) to run it. Ruben and Floyd's partnership was the beginning of an empire that would stretch from movie theaters to radio, broadcast television, cable television, and internet services known as Midcontinent Media.

Joe Floyd ran the Granada until he lost the lease in 1939 to Aberdeen businessman Art Johnson. In a 1987 interview, Floyd mused that Johnson "was always getting in someone's way." This takeover sent Floyd on his way to opening the Hollywood Theatre. Despite the dustup, Johnson and Floyd became good friends. (Courtesy Tom Johnson.)

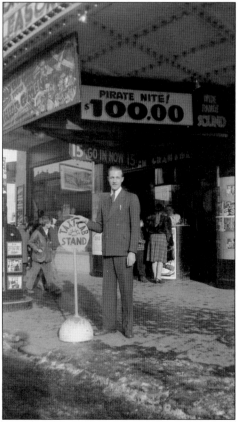

Next to the taxi stand is Helmer Rierson, a Sioux Falls native who served as assistant manager. The sign under the marquee advertises "Pirate Nite!" The promotion was one of the many attractions used to draw crowds in those days. Pirate Nite would later move to the Hollywood after it was replaced at the Granada by a bingo-like game called Wahoo! (see pages 118–121). (Courtesy Tom Johnson.)

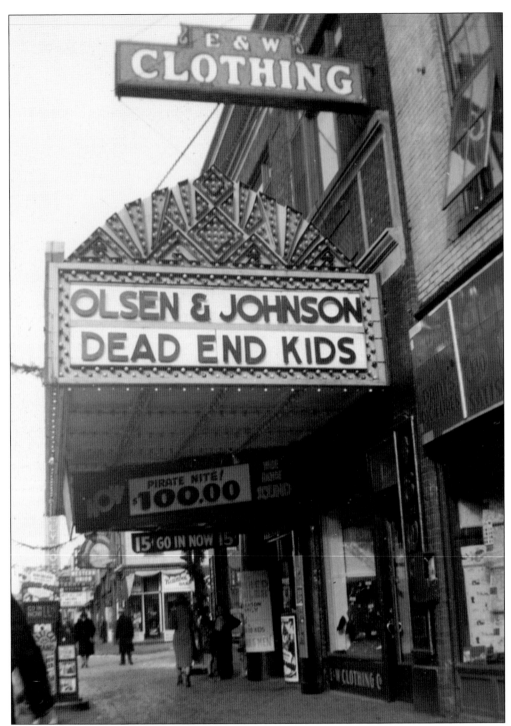

The Granada closed in July 1957. Art Johnson went on to run the Dakota Theater in Yankton. Joe Floyd was busy with KELO Television, but his company still ran the Hollywood and eventually other theaters for many years. The theater reopened as the New Strand in 1957, the Cinema in 1967, and the Downtown Cinema in 1972 before closing its doors for good in 1975.

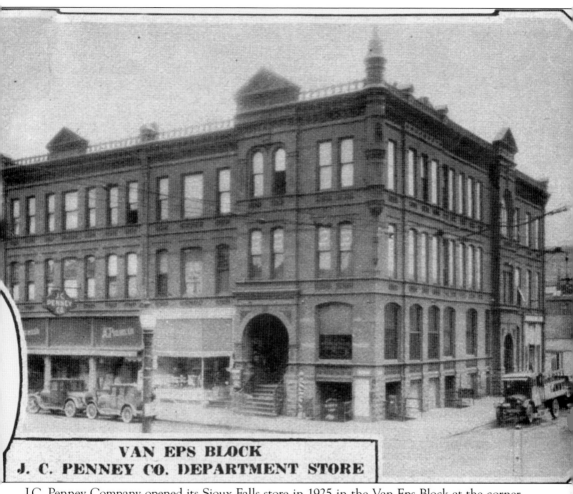

**VAN EPS BLOCK
J. C. PENNEY CO. DEPARTMENT STORE**

J.C. Penney Company opened its Sioux Falls store in 1925 in the Van Eps Block at the corner of Eighth Street and Phillips Avenue. By this time, Penney had more than 500 stores across the country, doubling that number by 1928. Manager E.F. Fahrendorf started out with 11 employees and a selling space of 4,800 square feet. By 1937, Fahrendorf had expanded his space in the Van Eps Block to 12,000 square feet and increased his staff to 55 people. J.C. Penney sold dry goods, dresses, shirts, and hats, kitchen utensils, and glassware, but their shoe department was perhaps the most popular. In 1937, they had enough seating for 32 customers, with six clerks to help them with their purchases. The increased square footage gave them more space and allowed them to build an entrance and storefront on Eighth Street. This entrance faced north and was built on to the west side of the Van Eps Block. The store occupied an L-shaped space around the rest of the building. By 1939, Penney's moved to a building once occupied by Fantle's and the Van Eps Block lasted until 1969.

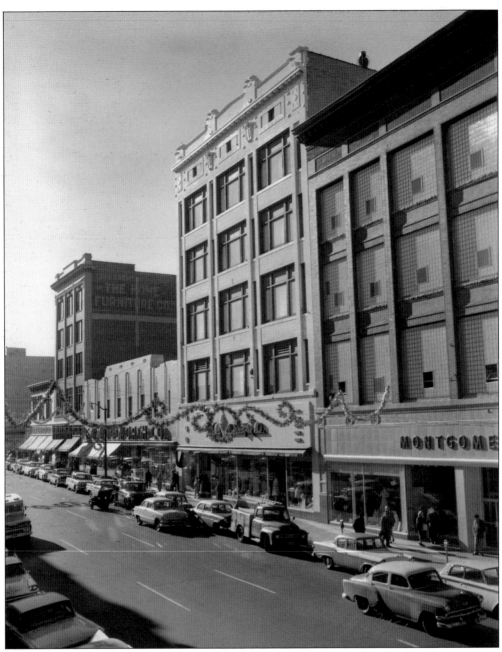

Fantle's department store operated out of this building on the west side of Phillips Avenue from 1915 to 1939, when they built their new building on Ninth Street and Main Avenue. J.C. Penney moved in at that time and kept moving their wares until 1975, when it became apparent that the Empire Mall was the place to be. One of the most popular attractions at J.C. Penney's downtown store was the escalator. (Courtesy Bill Pay.)

After World War II, Gene "Casey" Scribner was let go from Cessna Aircraft Company in Wichita—their subcontracting with Boeing had dried up after the fighting was over—and after seeing Herb Ottaway's Joyland Park and occasionally entertaining his son, Kent, there, he decided to start his own amusement concern in Sioux Falls, the hometown of his wife, Sylvia. Scribner purchased two miniature steam trains and a car ride from Ottaway. He set up his few rides at various places around Sioux Falls, including across from the Starlight Drive-In on Northwest Street (now Burnside Street), and at the northeast corner of Thirty-third Street and Minnesota Avenue, before purchasing the land that would become Joyland Park. In 1951, Scribner opened it at the southeast corner of Thirty-third Street and Duluth Avenue. (Courtesy Kent Scribner.)

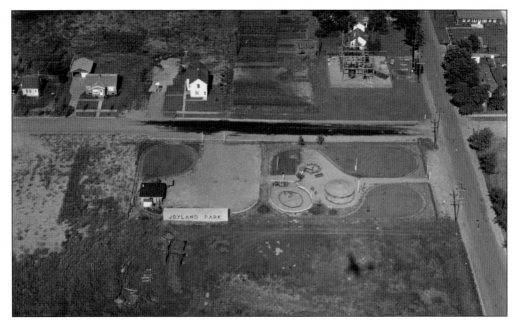

Duluth Avenue, running from left to right in this photograph, was still dirt at this time. Scribner oiled the road himself to keep the dust down. Notice the path of the train tracks, set up efficiently to give a nice, long ride through the park. The concrete block tunnel to the east side provided a thrill for young passengers and a shelter for the train during the rain. (Courtesy Kent Scribner.)

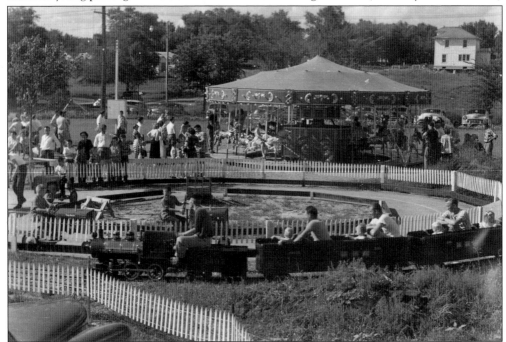

Here we see Joyland Park in full swing. The coal-fired miniature steam train is pulling kids around the park. The engineer had to arrive well in advance of the park's opening to get the engine sufficiently warmed up. Notice also the tractors being ridden within the train's loop, and the merry-go-round. (Courtesy Kent Scribner.)

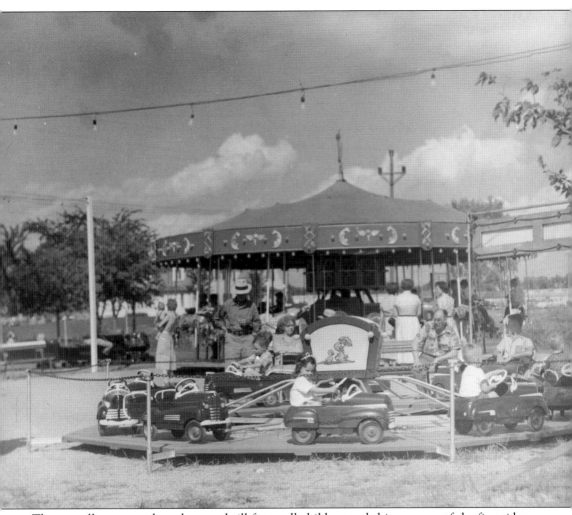

These small cars must have been a thrill for small children and this was one of the first rides Scribner purchased before opening the park. There was plenty of seating for adults around the rides at Joyland Park to make an afternoon spent here fun for everyone. (Courtesy Kent Scribner.)

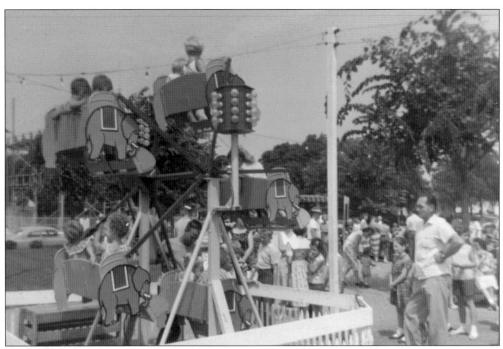

This has to be one of the smallest Ferris Wheels around. No more than 10 children could ride it at a time. Note the lights on the ride itself and the strings of lights hung around the park. (Courtesy Kent Scribner.)

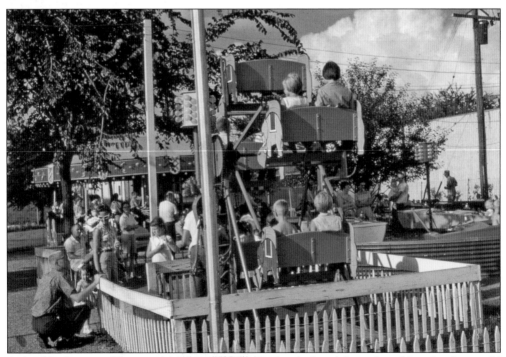

Joyland Park was well-lit into the summer nights for family fun. After a day of fun, families could run down to the Barrell for some ice cream. (Courtesy Jerry Parr.)

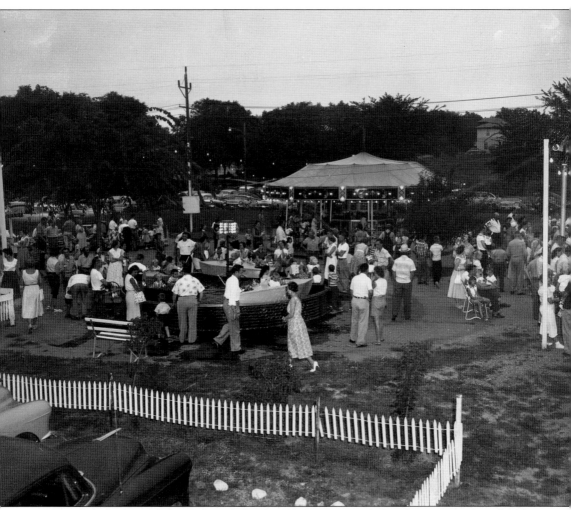

A boat ride was also added and it needed to be filled pretty regularly. The merry-go-round was a place for shelter when rain would occasionally fall on Joyland Park. Worker Jerry Parr recalls taking shelter there and getting the shock of his life when lightning struck the concrete train tunnel. He and the others were relieved that they were not the focus of the strike. (Courtesy Kent Scribner.)

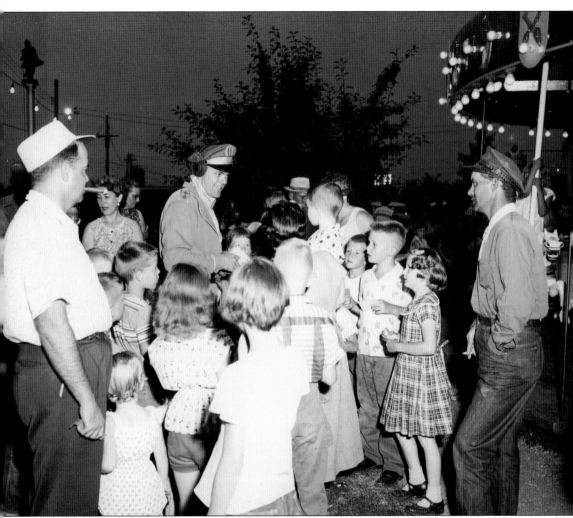

Joyland Park was an oasis for children in the early 1950s. KELO's television broadcasts did not begin until 1953, when almost nobody had a television. There was not a lot of organized fun for children in those days. March 7, 1955, brought Captain 11 to the air, and Joyland Park was a great place for some cross-promotion. (Courtesy Kent Scribner.)

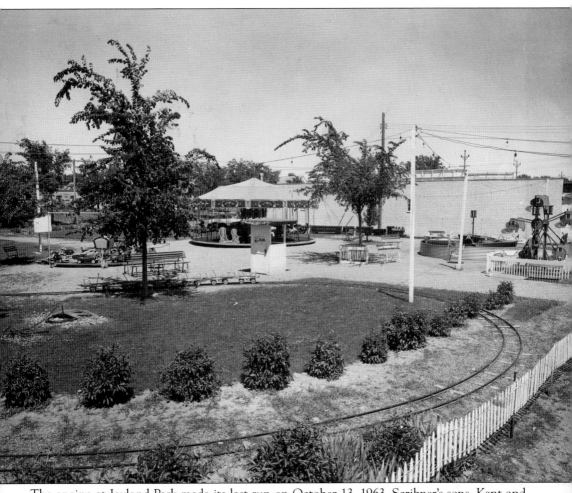

The engine at Joyland Park made its last run on October 13, 1963. Scribner's sons, Kent and Bruce, had gone on to military service and college while Gene had duties in the state house of representatives to attend to. The rides were sold to Burdette Melloon, who opened Lollipop Park at the junction of Highway 38 and East Twelfth Street the next year. (Courtesy Kent Scribner.)

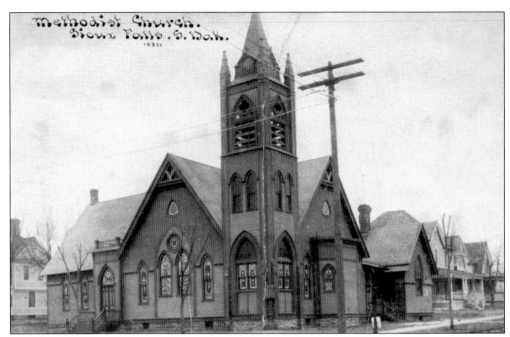

This beautiful church was built at the corner of Eleventh Street and Minnesota Avenue in the late 1800s. This photograph was taken after an expansion in 1902. The Methodists would eventually move to the building they now occupy at Twelfth Street and Spring Avenue.

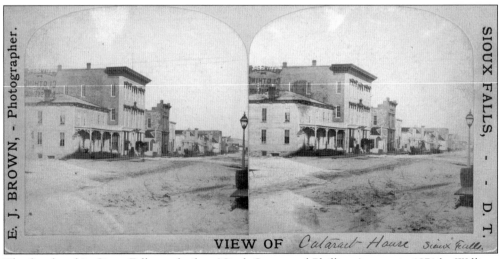

The first hotel in Sioux Falls was built at Ninth Street and Phillips Avenue in 1871 by William Henry Corson, who arrived via covered wagon with his family, purchased a piece of land from Dr. J.L. Phillips, and built this hotel. The first Cataract Hotel had 14 sleeping rooms and opened for business on August 5. (Courtesy John Gilliland.)

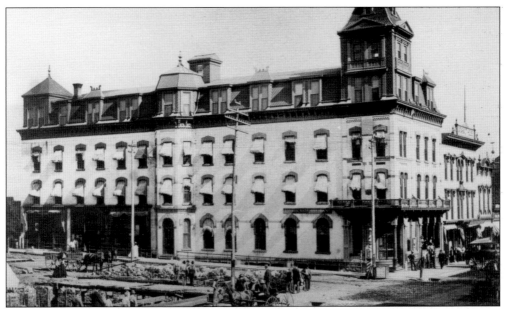

The second Cataract Hotel was built of brick to the north of the original building in 1878. This grand building is the Cataract's third building, built in 1884 and designed by renowned local architect Wallace Dow. Some of his other work includes the state penitentiary, the city auditorium, and the courthouse museum. The second Cataract House remained to the north. The first structure was moved into the street while the third was being built, eventually moving to a neighborhood on Duluth Avenue.

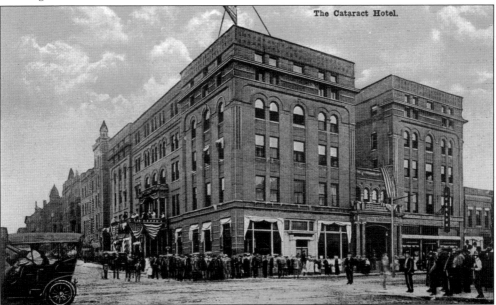

On June 30, 1900, fireworks on display in the front window of the Cataract Hotel caught fire and burned the building to the ground. This fire and others prompted the city to finally put together a full-time fire department. This building, the fourth Cataract House in Sioux Falls, was built in 1901 and designed by Joseph Schwarz. The Corson brothers began construction immediately after the fire.

This photograph shows some of the finer details on the Phillips Avenue entrance to the Cataract Hotel. In February 1909, Sioux Falls received 21 inches of snow over the course of two days. The walks in front of the Cataract Hotel were fully cleared, but neighbors down the street can be seen clearing their own walks. The city used elbow grease and horse-and-wagon labor to clear the streets.

The Cataract Hotel dining room was the place to be in Sioux Falls. The best steaks in town could be had here as well as other local and imported dishes. The dining experience at the Cataract Hotel lent to its fame as the finest hotel in the region and the nexus for local socializing.

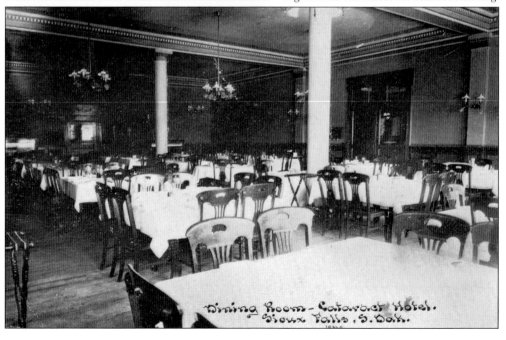

Dining Room - Cataract Hotel. Sioux Falls, S. Dak.

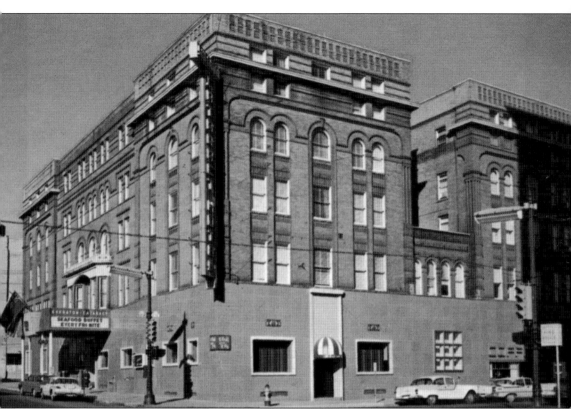

In the 1950s, many buildings in downtown Sioux Falls were given facelifts to make them more modern. What looks like a concrete brick pasted over Joseph Schwarz's most interesting architectural details is actually shiny granite. On March 12, 1973, the *Argus Leader* reported plans for the razing of the Cataract Motor Inn, the Lincoln Hotel (previously the New Chicago Hotel), and the Elks Club to make way for the future—and parking.

The early 1970s brought urban renewal just a few short years before programs like "This Old House" made it cool to renovate. In 1973, the Cataract was razed. In 1974, the entire block was erased to make way for Northwestern Bank and parking. Northwestern eventually changed to Norwest, which was subsumed by Wells Fargo.

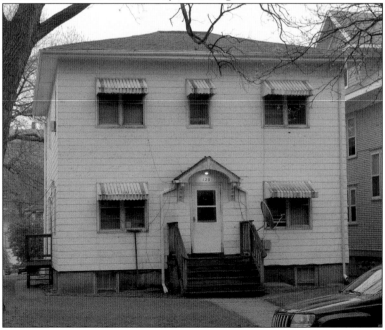

The first Cataract Hotel lives on as an apartment building on Duluth Avenue. There is no pomp and almost no resemblance to the original building (see page 44), but so far, the Cataract Hotel lives on in some small way. Hopefully, this bland old gal will survive the latest efforts to clean up the neighborhoods in its area.

# *Two*
# STILL HERE

A good number of buildings in Sioux Falls survived the cancerous scourge that was urban renewal. Many of them have gone through trying times while the city discovered what to do with them. Some have come perilously close to being torn down and lost forever. All the buildings in this chapter have survived and found a place to scratch out at least a meager existence. At best, they have been able to soar to new heights and rival their former glory.

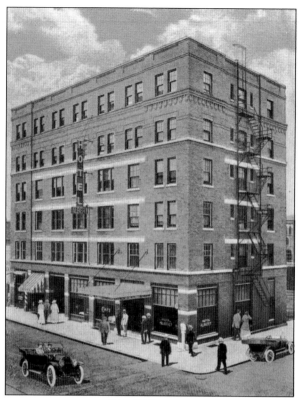

The Albert House (left and below) was built in 1912 to replace the Merchants Hotel, which burned down that year at the same location. The Merchants Hotel was nearly destroyed by flood in 1881 and holes had to be made in the walls to allow the waters to flow through. The Albert House survived urban renewal because, in 1975, federal tax codes were altered to provide incentives for fixing up buildings of historical importance. The Albert's 80 rooms were altered to make 20 efficiency apartments and 40 sleeping rooms. Of those rooms, 16 were to be rented to the elderly under a community development project. The Albert House still stands, renting out efficiency apartments.

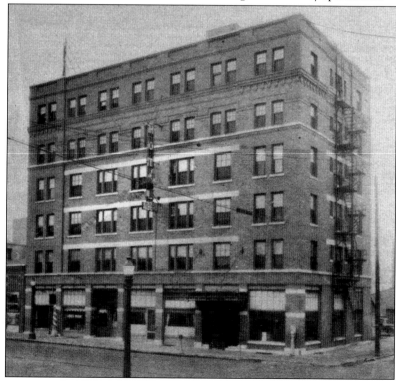

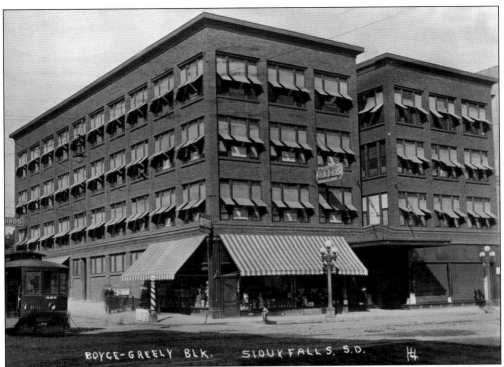

The Boyce-Greeley building at Eleventh Street and Phillips Avenue was built in 1910 by Jesse Boyce and George Greeley. The building's two lobes were built by different construction crews, though both sides use a common entrance. Though the street-level store space has been occupied through much of its existence, the upper floors are just now filling up with new tenants.

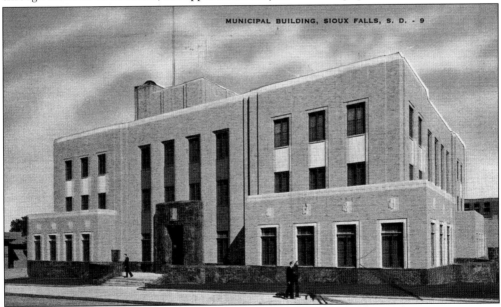

City hall stands on the ground once occupied by the city auditorium and Germania Hall, where state constitutional conventions hammered out the details of South Dakota's proposed statehood. City hall was designed by Harold Spitznagel in the Art Deco style and completed in 1936.

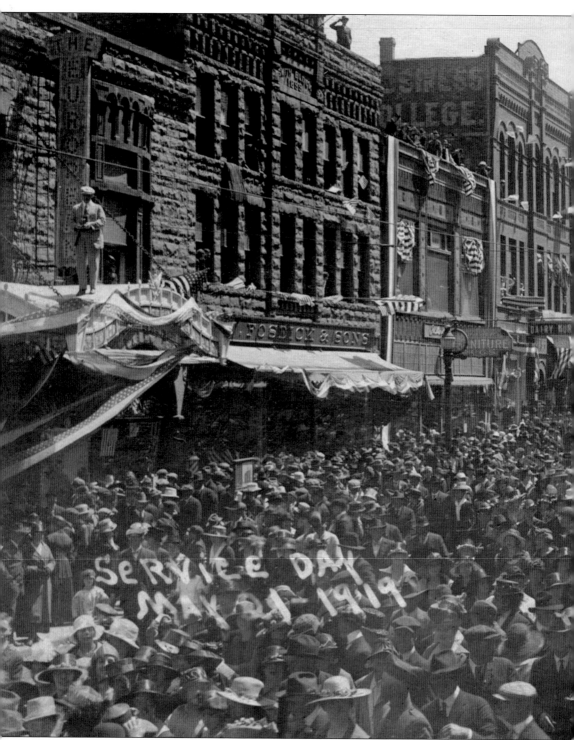

The Hotel Carpenter (upper right) had literature stating that it was "positively the leading and only fireproof hotel in Sioux Falls." This was practically shouted from the rooftop with the enormous sign that hung over the street for the first few years of its existence. While it may not have been

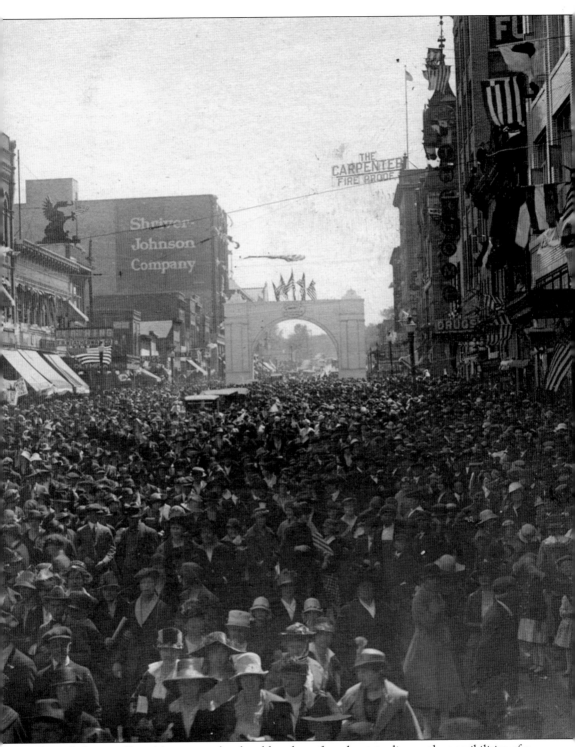

the only fireproof hotel in town, other local hotels preferred not to discuss the possibilities of a fire breaking out while guests slept.

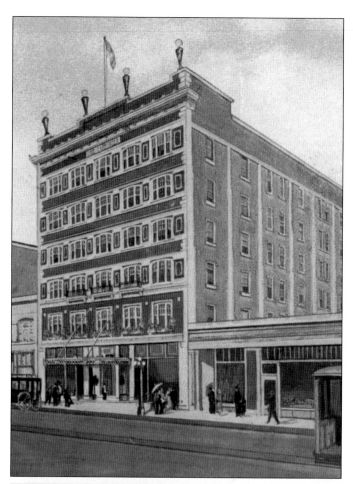

On Tuesday, October 15, 1912, the Hotel Carpenter opened its doors for the first time. It was established as a hotel on the "European plan," meaning that meals were not included in the price of lodging. This situation encouraged those who stayed to either try the food in the Carpenter's restaurant or venture out and explore the other culinary experiences available in the area.

The postcard below shows the beautiful and spacious lobby of the Hotel Carpenter shortly after it opened. There were plenty of large, leather chairs to relax in, and plenty of spittoons to keep the floor clean. Toward the right rear was a counter where one could purchase one of the many locally made cigars available.

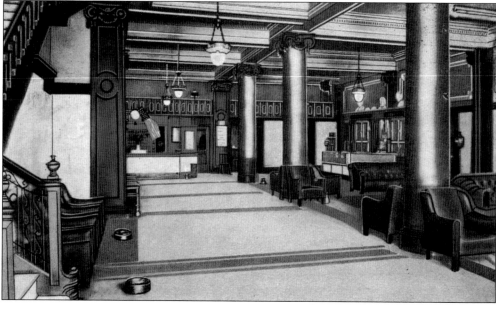

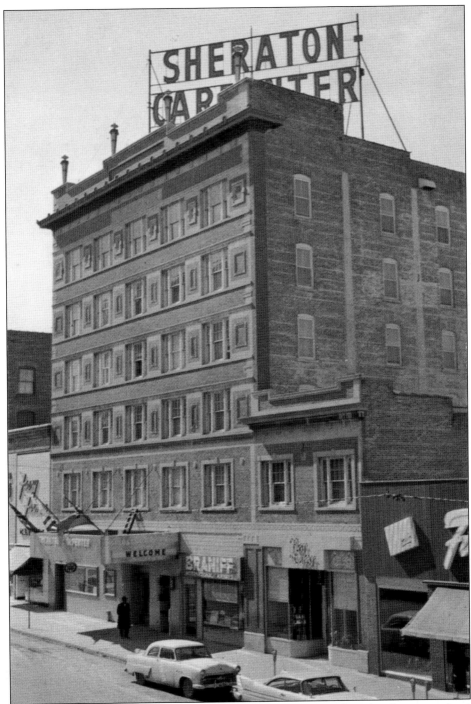

The Hotel Carpenter is seen here after a 1940 remodel. The first-floor facade was modernized by architect Harold Spitznagel, who used the same porcelain enameled steel panels here as he did for the Hollywood Theatre and Sport Bowl. This facade lasted until 1997, when the former facade was restored to its past glory. Today, the Carpenter has businesses on the ground floor and second floor and apartments above.

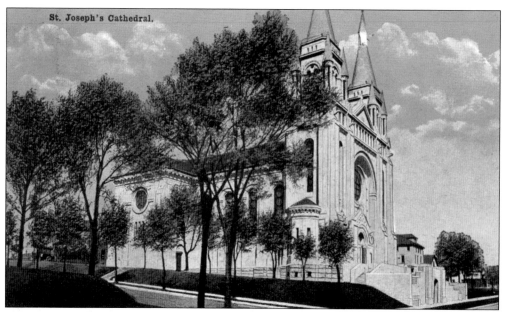

St. Joseph's Cathedral.

St. Joseph's Cathedral, designed by French architect Emmanuel Masqueray, was the project of Bishop Thomas O'Gorman, for whom O'Gorman High School is named. O'Gorman wanted a focal point for the Sioux Falls diocese, a territory that covered all of eastern South Dakota. Building began in 1915 on the site of St. Michael's Church, which was moved for the project. In May 1917, two years before the project was complete, Masqueray died and his assistant, Edwin Lundie, was retained to complete the job. The cathedral was completed on May 7, 1919, at an estimated cost of $390,000, which was $115,000 more than the original projection. After 77 years of use, the diocese decided to undertake a restoration project to bring the cathedral back to its former glory. The restoration officially concluded with the blessing of the doors and altar on July 25, 2011.

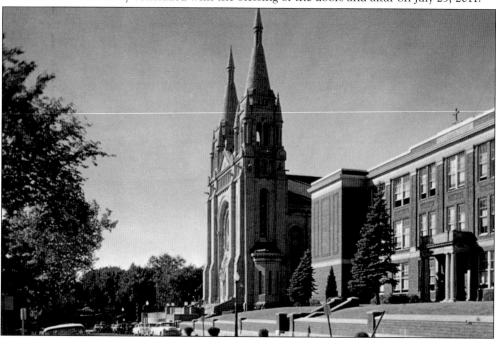

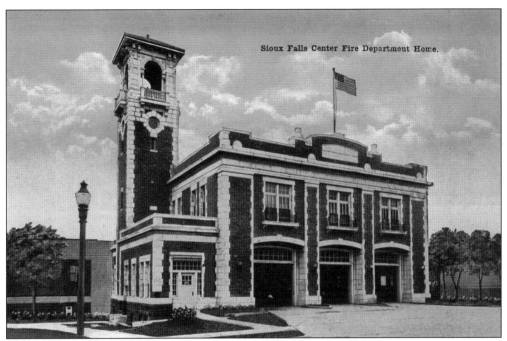

Sioux Falls Center Fire Department Home.

The central fire station at Ninth Street and Minnesota Avenue was built in 1912, providing the fire department with a building of their own. The fire department had been housed in the city auditorium up to this point, but had run out of room. The bell that once rang from the top of the auditorium was moved as well and currently stands in front of the building. Before the fire department moved to motorized fire trucks in 1917, there were 11 horse stalls to the rear of the building and a hay loft on the second floor. The horses were trained to get into position in front of the fire wagons when the alarm bell rang. The central fire station once provided winter housing for the animals of the Sioux Falls zoo.

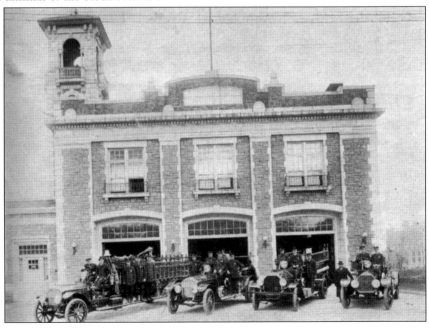

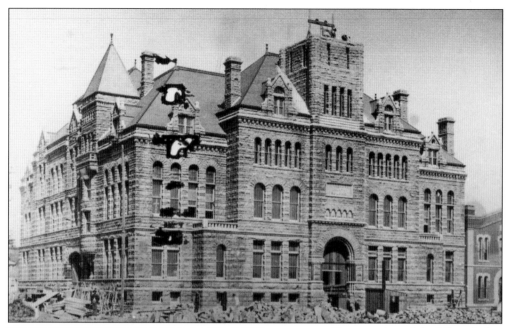

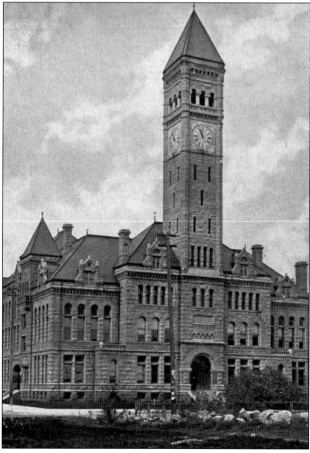

Construction of the Minnehaha County Courthouse began in 1889. County business had been handled in the Sherman Block up to that point. The courthouse was designed by Wallace Dow in the Richardsonian Romanesque architectural style he seemed most fond of. Built of Sioux quartzite, this imposing structure is perhaps more indicative of Sioux Falls than any other structure. County business eventually outgrew the building, and in 1962, a new courthouse was built on Minnesota Avenue. Razing the old courthouse in favor of parking was seriously considered in the years that followed, but thankfully cooler heads prevailed. Instead, the structure was converted into a museum, though some of its former courthouse functions were preserved and one can still visit the restored circuit courtroom and law library. The courthouse museum and the Pettigrew museum are now owned by Siouxland Heritage Museums.

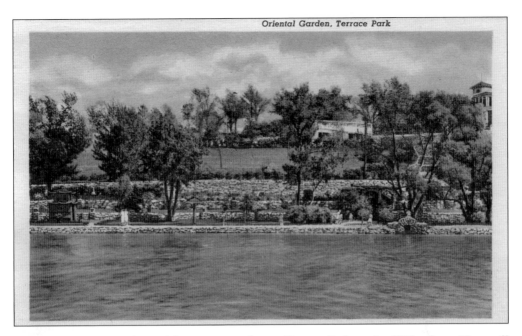

*Oriental Garden, Terrace Park*

Joe Maddox created a beautiful Japanese garden in Terrace Park in the 1930s. *Better Homes & Gardens* awarded it their "More Beautiful America" award in 1934. During World War II, there was a bit of negativity toward the Japanese, which is why this card was labeled "Oriental Garden." These tactics did not prevent vandals from ruining the beautiful fruits of Maddox's labor. By the mid-1980s, the Japanese Gardens at Terrace Park were vaguely recognizable as such, but it was clear that the area was not cared for. In 1988, a group of gardeners gathered together to bring the area under their collective wing. Today, it is greatly improved and getting better all the time thanks to the help of expert Ben Chu and a group of dedicated enthusiasts. It is currently known as the Shoto-Teien Japanese Gardens.

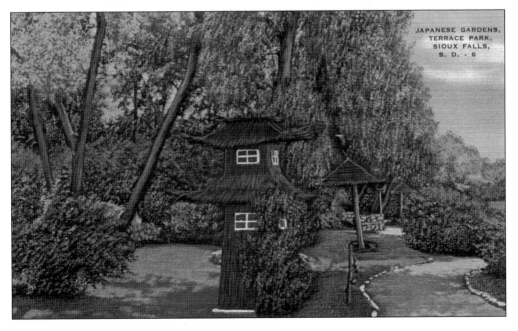

JAPANESE GARDENS, TERRACE PARK, SIOUX FALLS, S. D. - 6

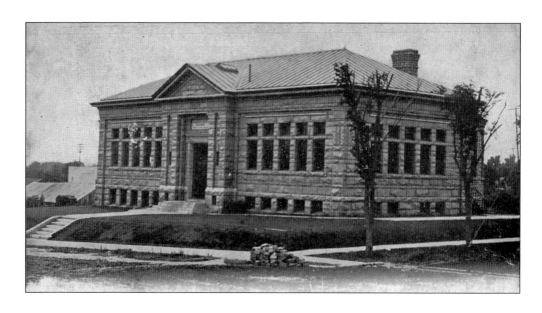

Sioux Falls's first library building was a former church at the corner of Twelfth Street and Dakota Avenue. This was used from 1899 to 1903, when a new library was built at Tenth Street and Dakota Avenue, with the help of a $30,000 boost from steel magnate Andrew Carnegie. The Carnegie Free Public Library served the city for 70 years but eventually started running out of room. The children's department was moved to a remodeled grocery store on Phillips Avenue in 1954. The city started putting aside funds for a new library in 1965, and by December 1972, the 46,600-square-foot, $1.5 million library below was completed at 200 North Dakota Avenue. In 2010, a remodeling project was completed to boost its size to 61,832 square feet. The Carnegie building is still in use by the city. (Bottom Courtesy Mark Helberg.)

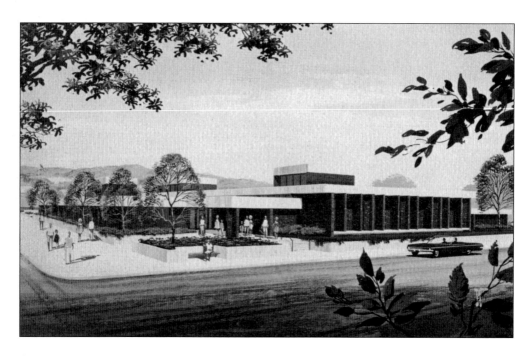

Friday, November 21, 1980, marked the grand opening of the New Town Mall. This proud sign once marked the parking lot of the mall and stood for more than 10 years. It may have been an iffy move to create another mall in the same general area of the Western Mall (1968) and the Empire Mall (1975), but try to stop progress. (Courtesy Mark Helberg.)

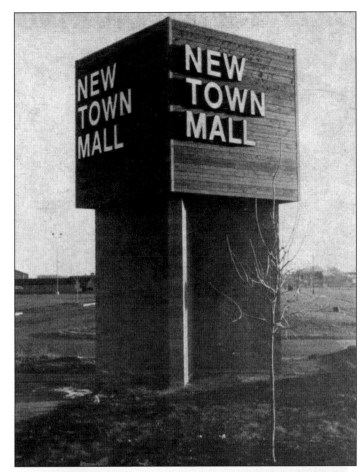

Below is the beautiful center court that served as the hub of the New Town Mall. It does not look much different now, though the barrel-shaped skylight is now in the middle of Kohl's and is covered. This view looks south. At the far end of the hall is an exit; obscured by trees is the entrance to the New Town 6 Theaters on the left. (Courtesy Mark Helberg.)

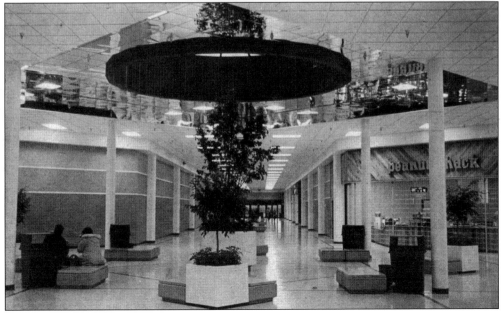

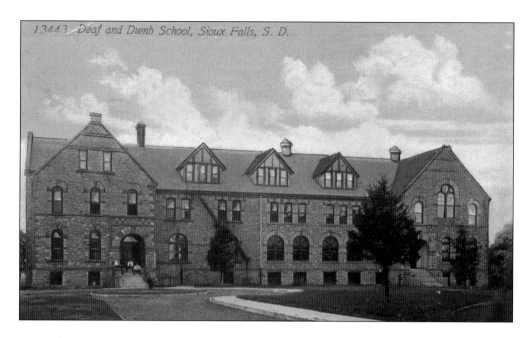

The Dakota Territorial School for Deaf Mutes was started in 1880 with just a handful of students. By the time South Dakota became a state in 1889, the renamed South Dakota School for the Deaf and Mute had 54 students. All the early buildings were designed by architect Wallace Dow. The land for the school was donated by Edwin A. Sherman, the cofounder of Minnehaha National Bank for whom Sherman Park is named. The school had acres of land, which it used for farming and dairying; students were trained in those skills as well as in tinning, printing, and carpentry. The South Dakota School for the Deaf still stands today and operates from the same buildings built in the 1880s.

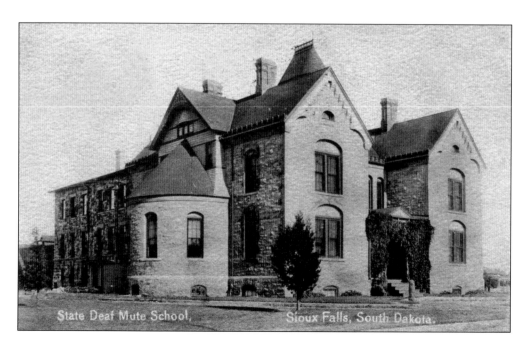

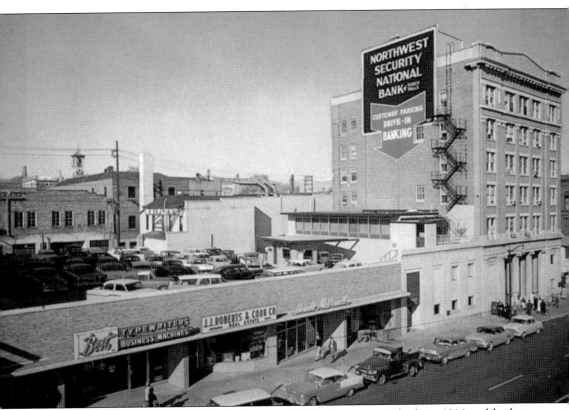

The Security National Bank at Ninth Street and Main Avenue was built in 1916 and had a good record of keeping its customers' money safe, up to a point. On March 6, 1934, six men in a green 1934 Packard screeched up in front of the bank and took a reported $46,000 before taking five bank employees as hostages, using them as human shields, and fleeing to the east. Some believe John Dillinger and his gang did the job, though police officers at the time stated that he did not. Security National Bank later changed its name to Northwestern Security National Bank before later dropping the "Security." This postcard shows the aboveground parking offered downtown. Parking downtown has always been a valuable commodity. Today, the building is used for commercial space and apartments.

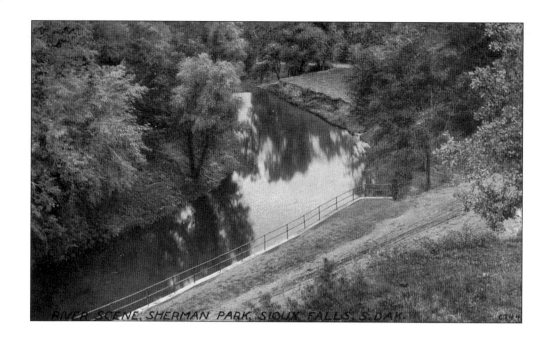

Sherman Park was one of the first parks in the city. The 52 acres were donated by Edwin A. Sherman and his wife, Katherine, on the stipulation that no "intoxicating liquors" be allowed in the park. Sherman was a longtime advocate of city parks, and his legacy lives on in many of our current parks. Sherman donated the land in 1910, having owned it since 1886 and feeling some amount of guilt for enjoying it by himself. Sherman believed that in order to be a great city, Sioux Falls needed not only business but also a thriving park system to attract families to the area.

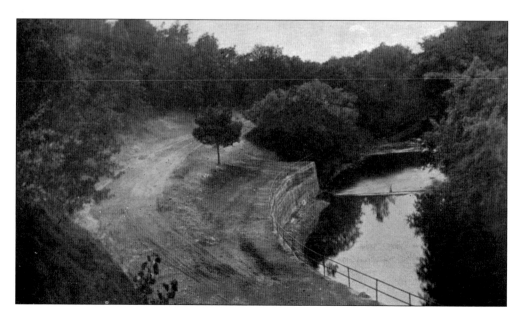

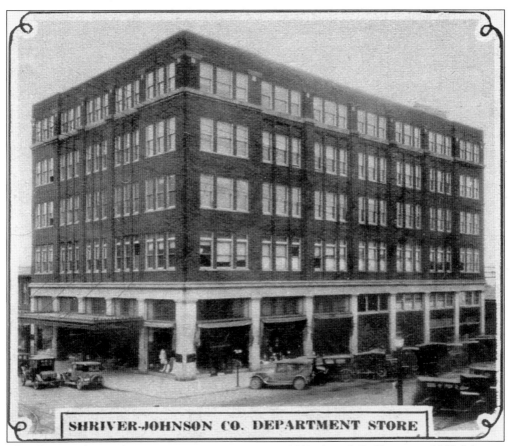

SHRIVER-JOHNSON CO. DEPARTMENT STORE

The Shriver-Johnson department store got its start in 1914 when A.R. Shriver and J.H. Johnson purchased the Koenig store at 117 North Phillips Avenue, about a block and a half north of the Cataract Hotel. Four years later, they built this 89,900-square-foot building with five floors and a basement. The staff boomed from 11 in the old store to 150 in the new location. The Shriver-Johnson department store boasted two cafes, a post office, restrooms, air conditioning, and an amazing selection of wares. The building was designed in the Classical Revival style by Perkins and McWayne and is listed in the National Register of Historic Places.

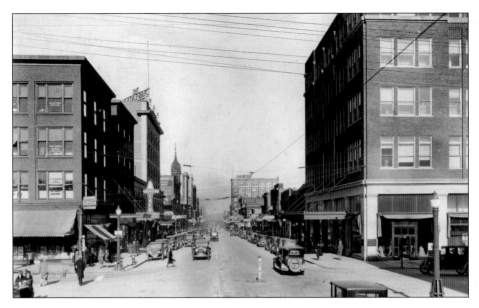

Shriver-Johnson department store (above, right) was a downtown anchor. The first floor was a real attention-getter. There were electric lights for night and enormous windows to let in plenty of light during the day. Awnings were used to keep the summer heat under control. The tall ceilings and hanging plants give an airy feel to the first floor. The second floor had overhead tubes for cash transactions. The salesperson would send your cash off in a pneumatic tube, the sort now used for drive-through banking. Moments later, your change would return, along with a receipt for the purchase. This system was used until at least the mid-1950s. On March 25, 1979, Shriver's moved to 40,000 square feet in the Western Mall, ending the store's 65-year-run downtown

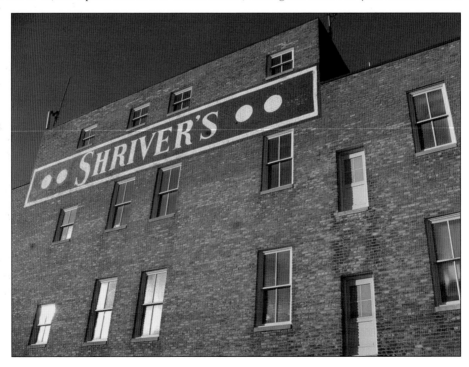

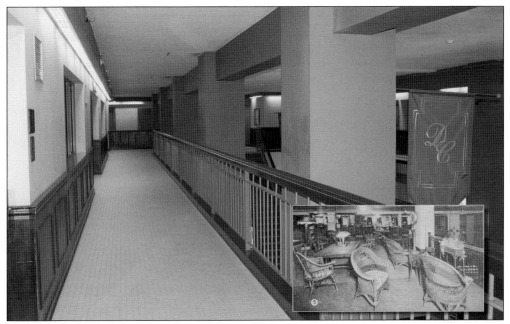

With a beauty parlor, children's haircuts, a post office, a writing room, restrooms, a lounging room, a nursery, and more, the mezzanine was a massive attraction at the Shriver-Johnson department store. "Meet me on the mezzanine, Shriver Johnson Co." was the hook used in advertisements to bring women into the store. Keep in mind that in 1918, restrooms did not mean there were just toilets and sinks; it implied actual rest with couches, chairs, and a maid in attendance.

The basement was for ladies' apparel and it seems less hospitable than the mezzanine, with no windows and thick foundational pillars. Parts of the basement were used as a civil defense fallout shelter during the Cold War. There were large tins of biscuits, medicines, and barrels in which to keep potable water.

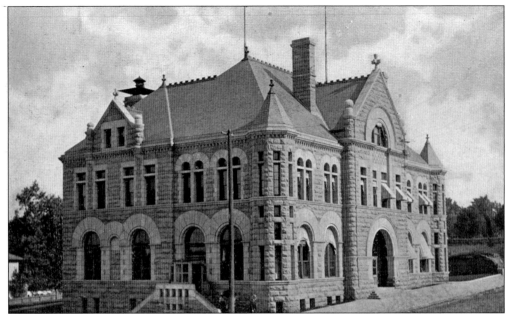

The grand building at the southeast corner of Twelfth Street and Phillips Avenue was originally a post office and federal courthouse. Today, the postal functions once performed on the first floor have been moved to a different location. In 1891, South Dakota's first senator, Richard Pettigrew, introduced a bill to obtain the funding for this building. The bill showed that westward expansion across the country was a reality and the federal government needed to support it. Opinions differ on who the architect was. A historical marker at the site claims it was Wallace Dow, but other sources claim it was an architect named Willoughby J. Edbrooke, the supervising architect of the treasury. The latter seems more plausible as the local museums cannot confirm that it was Dow and it was quite a visible project.

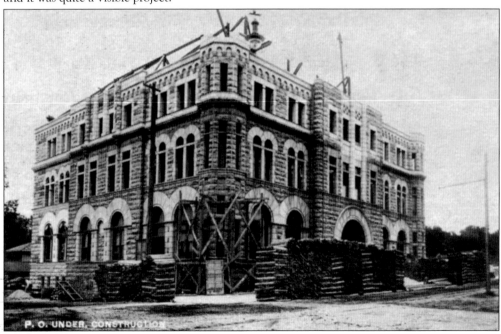

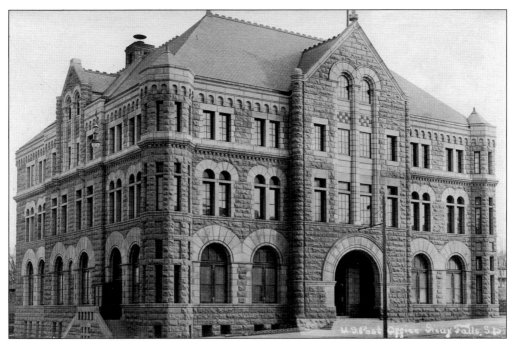

The post office and courthouse was built using Sioux quartzite in the Romanesque style, which matched well with other buildings in the area, namely the county courthouse. In 1913, a third floor was added to help accommodate the needs of the growing populace and their federal legal issues. An eastern annex was added to the building, also in the Romanesque style of the original building. In 1966, the post office was handling more mail than they could easily process and a new post office was built at Twelfth Street and Second Avenue. It is still one of the most advanced sorting facilities in the region.

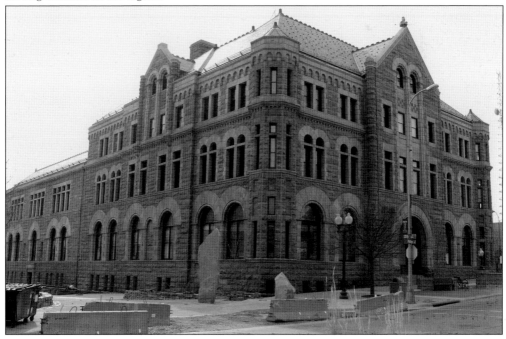

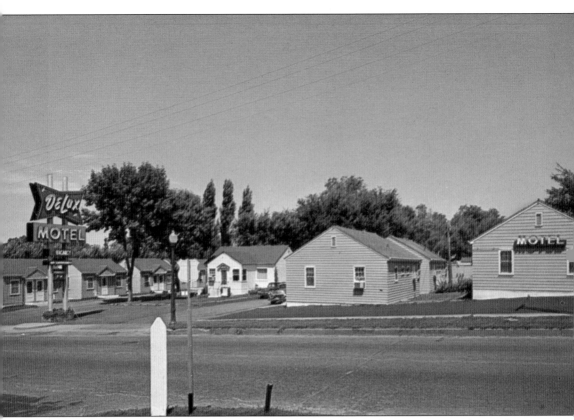

The De Lux Motel at 1712 West Twelfth Street has seen better days. It consists of several tourist cabins, with individual buildings for each guest. Today, though many of these cabins have been joined together and its once fantastic sign no longer has working neon, it still operates as a motel.

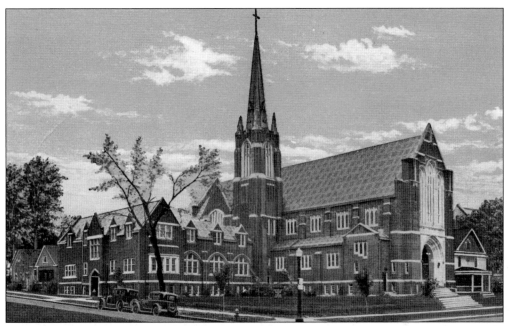

This postcard shows First Lutheran Church, at Twelfth Street and Dakota Avenue. The cornerstone was laid on May 3, 1925, but the building was not dedicated until November 30, 1930, due to fundraising problems in the tough economic climate of the time. The church is still there at 327 South Dakota Avenue as of this writing, but it is quite a bit bigger now.

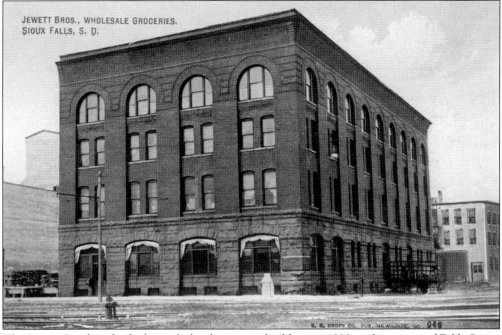

The Jewett Brothers built their wholesale grocery building in 1899 at the corner of Fifth Street and Phillips Avenue with easy access to the rail yards. In fact, there was a dock just across the Street. In 1927, when the Jewetts retired, they sold the building to their competitors, Nash Finch. The building has since been used for restaurants and business offices.

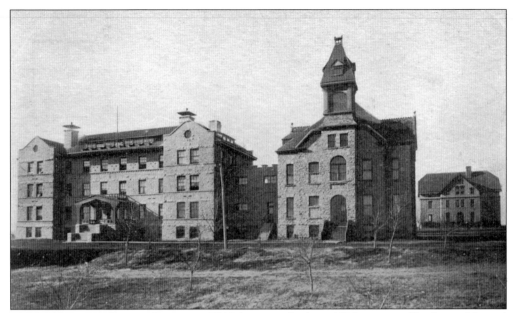

The building at right, now known as Old Main, was built in 1889 as part of Lutheran Normal School. In 1918, it was decided that the Lutheran Normal School and Augustana College in nearby Canton would merge to be called Augustana College and Normal School in Sioux Falls. In 1926, they shortened the name to Augustana College. Old Main is currently uninhabited.

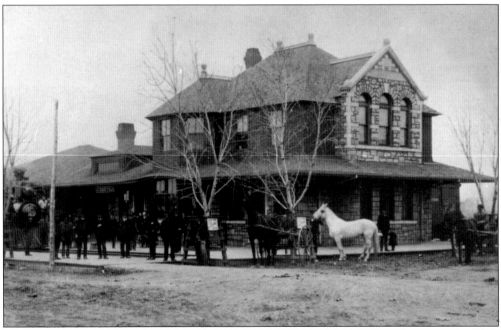

This building, once the Burlington, Cedar Rapids & Northern depot and later known as the Rock Island depot, was built of Sioux quartzite and served in its capacity as a junction for interstate commerce for many years before being left vacant in 1970. It was later used as a restaurant and a bar before becoming the Great Outdoor Store.

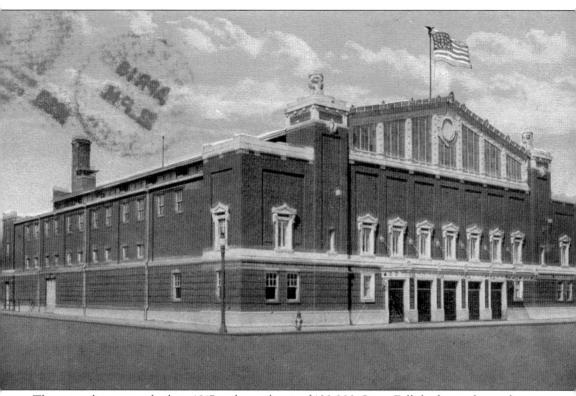

The city coliseum was built in 1917 and cost the city $120,000. Sioux Falls had a need to replace the crumbling city auditorium that had been the place for conventions and other gatherings since 1899, when it was hastily assembled for the Buttermaker's convention. In 1919, Woodrow Wilson came to Sioux Falls and spoke to a packed coliseum on a tour promoting his League of Nations.

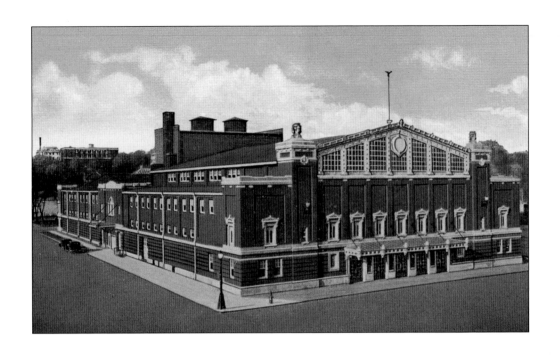

In 1932, an eastern annex tripling the coliseum's floor space was completed. It was promoted as a great place for performances, expositions, conventions, and more. The coliseum contained 13,000 square feet of floor space, sat 1,800 in removable chairs on the floor and 1,200 in the permanent seats on the balcony. Seats on the main floor could be placed on an incline or removed so that a flat area could be used. The stage was 75 feet wide, 40 feet deep, and 60 feet high, providing enough space for virtually any performance. The annex added 23,000 square feet of floor space to the coliseum, with space to seat 7,000. A large 50-foot-by-90-foot wooden floor was built for basketball, indoor tennis, or dancing, and there was a modern, fully-equipped kitchen in one corner of the annex for banquets.

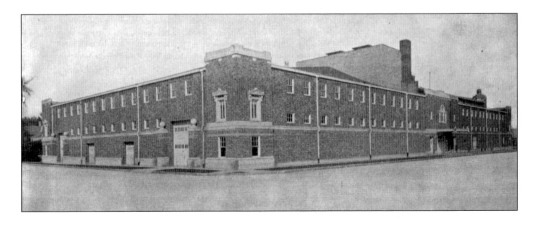

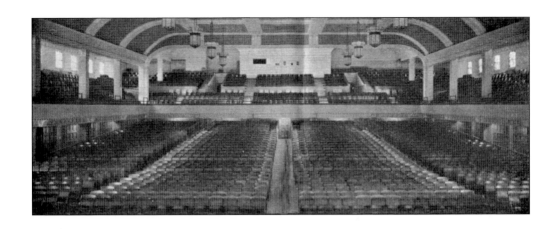

With space in the coliseum to seat 3,700 and free-standing space for many more, Sioux Falls fashioned itself as a great place for conventions and other gatherings, calling itself "The Meeting Place for the Northwest." This slogan was emblazoned on the side of the chamber of commerce, in full view of Phillips Avenue near Tenth Street, for years. The only problem with this situation was that the coliseum could hold more people than local hotels could put up. There were a good number of hotels downtown, three of which were relatively large, but there was not quite enough room.

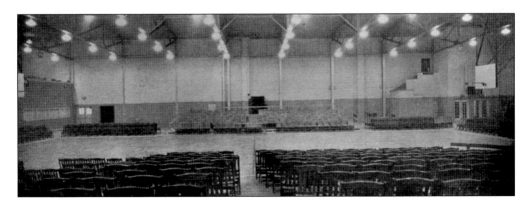

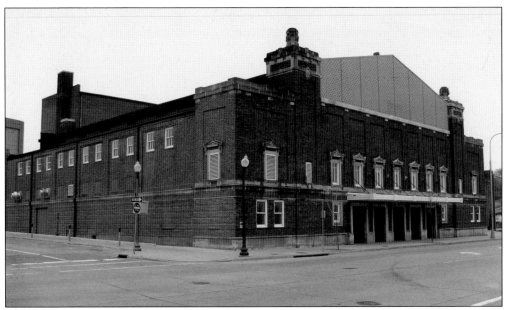

On February 18, 1994, a good portion of the coliseum's ceiling fell in, crushing a dozen or more seats. At this point, the city shut down the building and assembled a task force to decide what should be done. The city first decided to raze the building, then thought better of it, thinking they would tear down the attached recreation center for parking and renovate the main building. Then they were back to tearing it down. In a close public vote in April 2001, the coliseum was saved from the wrecking ball. In 2002, Gov. Bill Janklow announced a $1.7 million restoration project to restore the interior for use as a multicultural center. In 2009, an exterior restoration project began to replace the metal panels with historically accurate windows, bringing it back to its 1917 appearance.

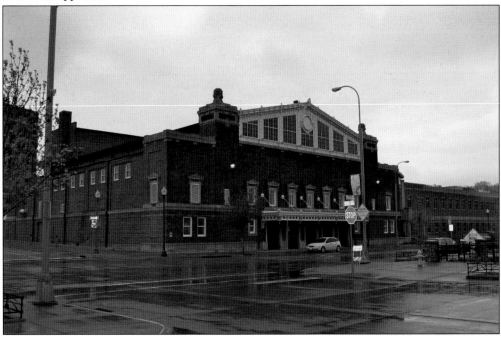

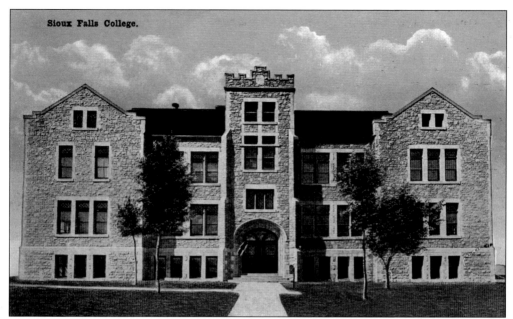

Sioux Falls College.

On June 5, 1872, delegates of nine Dakota Territory Baptist churches met in Vermillion, South Dakota, to put their efforts into creating a college. In September 1883, instruction began in the basement of First Baptist Church in Sioux Falls. In 1885, its first building, Meredith Hall, was completed. Jorden Hall, seen here, was built a bit later and still survives today. Meredith Hall lasted until the mid-1960s.

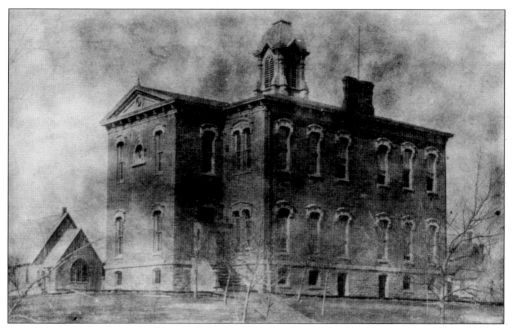

In 1878, this school was built to replace Sioux Falls's first school at Eleventh Street and Main Avenue. This new school was named Irving School but was later changed to Central High School. In 1904, the city passed a bond issue to build a new high school. The new building was to the north of Central High School and both buildings were used for a time.

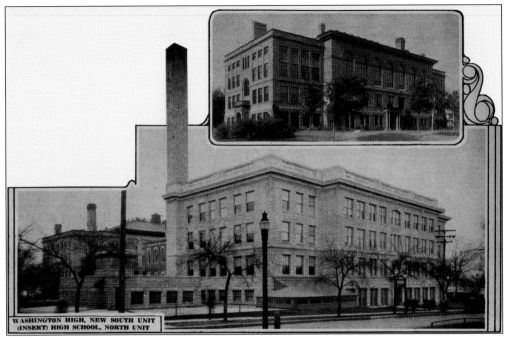

WASHINGTON HIGH, NEW SOUTH UNIT
(INSERT) HIGH SCHOOL, NORTH UNIT

On February 5, 1908, the new high school opened in the new building facing Eleventh Street. Central High School remained to the south of the new building, which had a capacity of 500 and was outgrown in just a few years. It was decided to build a south building in 1918 to handle this growth. The Central High School building remained between the two for years to come.

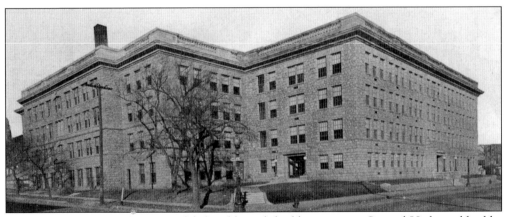

In 1932, plans were made to remodel the old north building, remove Central High, and build a central unit to connect the north and south buildings. The full building opened in 1936 with a capacity of 3,800 students, covering an entire block. It sported a new auditorium with seating for all 3,800. In 1992, the old Washington High School produced its last graduates.

On March 1, 1926, State Theatre owners M.L. Finkelstein and I.H. Ruben placed a full-page ad in the *Argus Leader* to promote the opening of their new motion picture and Vaudeville venue. By this time, Finkelstein and Ruben had nearly 90 theaters in North Dakota, South Dakota, Minnesota, and Wisconsin. The ad proclaimed it to be "Glorious as Fairyland, yet sturdy as the pyramids!"

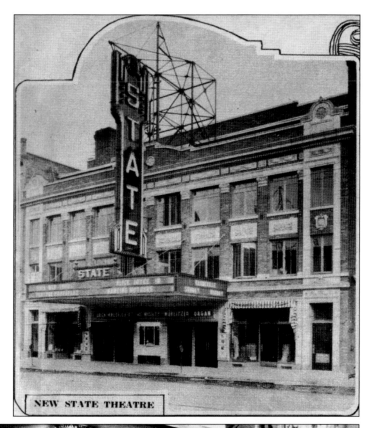

NEW STATE THEATRE

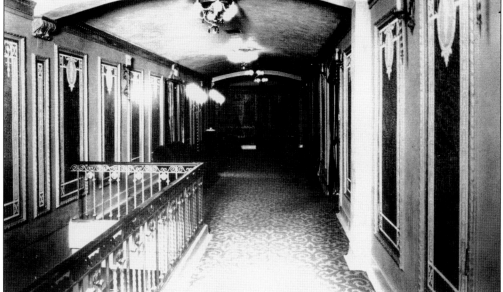

The area outside the balcony of the State Theatre mezzanine is seen here in 1936. During intermissions, one could come here to use the restroom, sit on a couch, and perhaps smoke a cigarette. It is spacious and beautifully decorated and still looks essentially the same. The carpet was thickly padded for maximum silence.

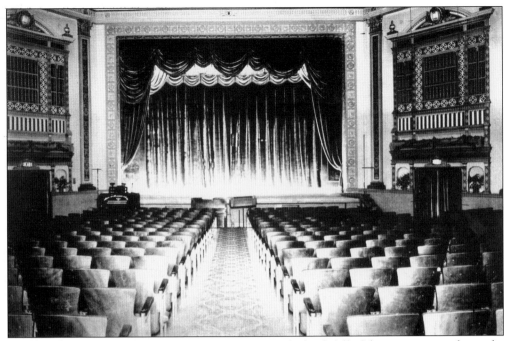

To either side of the stage were the organ chambers, each chock full of the apparatus used to make the sound effects and music for the silent films of the 1920s and 1930s. The Mighty Wurlitzer can be seen in front of the stage on the left.

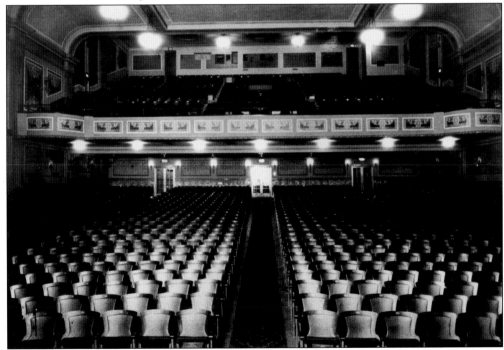

The view from the stage is seen here in 1936. Imagine being up on that stage and seeing 1,350 faces looking up at you. Many actors who performed in Vaudeville acts at the State Theatre did just that. In a 1958 remodel, the center aisle was removed and more seats were added.

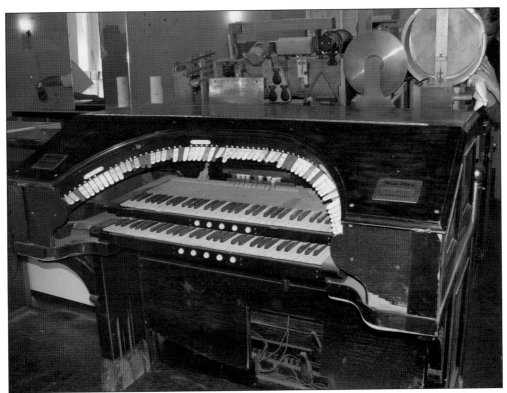

The State Theatre's own $25,000 Wurlitzer organ was used in the era of silent movies to provide music as well as sound effects for the show. Though it was used for musical entertainment before the films rolled, it fell into disuse not too long after being installed as talking pictures came into vogue.

This is a detailed shot of the Wurlitzer. In 1974, Elk Lake, Minnesota, organ enthusiast Ron Black bought the State's Wurlitzer from the Plitt Theater Company, who owned the State at the time. Black had planned to install the organ in an addition to his house, but never got around to it. When he was contacted in 2005 by State Theatre board member Glenn Nelson, he decided that he would like to return the organ to its original home in Sioux Falls. It is a rare and wonderful thing for restored organ-age theaters to be equipped with their original organ.

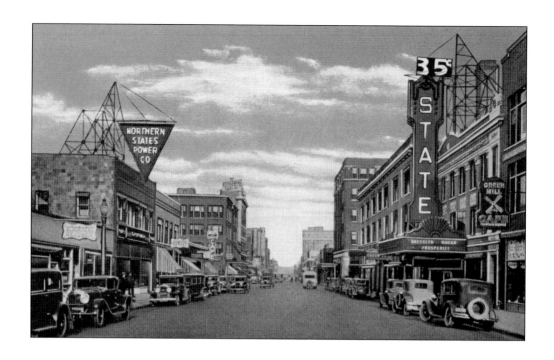

The above image shows Phillips Avenue facing north. To the left, Lewis Drug opened its first store in 1942, just beyond Northern States Power. Theater patrons would get popcorn at Lewis and bring it with them to the State before the State sold concessions. Management changed that policy pretty quickly. Certain movies would be welcomed by lines wrapping around the block.

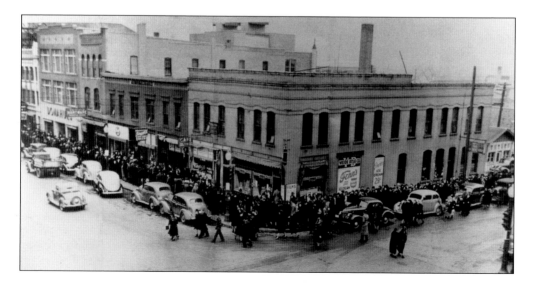

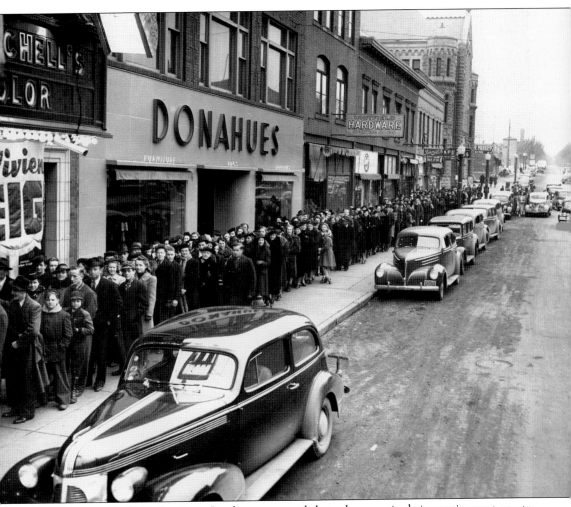

On February 13, 1940, the *Argus Leader* announced that a long-awaited cinematic event was to occur on February 25. *Gone With The Wind*, the film adaptation of Margaret Mitchell's wildly popular Civil War novel, was coming to the State Theatre. Tickets were available for a premium price and no lower until 1941; they charged $1.13 per ticket, up from the usual price of 25¢. The State was Sioux Falls's premium movie house and 25¢ was already the highest price among the movie houses in town. Despite the cost, people lined up around the block to get tickets. The State Theatre's 1,350 seats were packed for most showings. The film ran from February 25 to March 6 before it had to move on. In 1941, it came back for six days at the more reasonable price of 50¢.

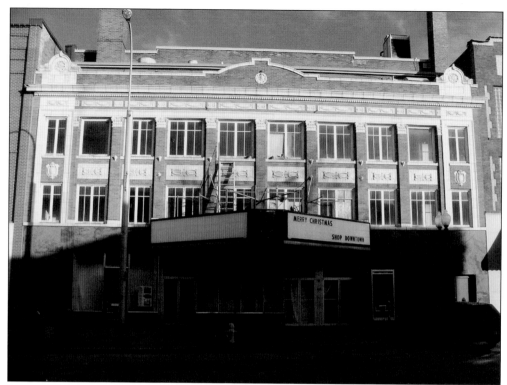

January 15, 2006, saw the theater in quite a state. The first floor facade was covered in granite during a 1950s remodel in an attempt to modernize the old girl. As with the Cataract and the Minnehaha buildings, this only succeeded in hiding the beauty beneath. The large, flashy parts of the sign had flown to Las Vegas to have some glitz restored, and returned in April looking fabulous.

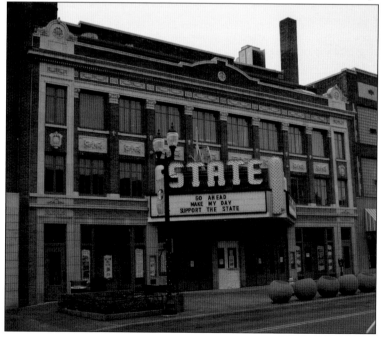

In September 2006, the State Theatre looked even worse, as the granite was torn out, leaving her tender lobby exposed. The State had been granted a new facade by the city's Facade Easement program and work was under way to bring the front back to its 1926 glory. With the roof replaced, the Marquee repaired, and the lobby restored, there is good momentum to bring films back to the State.

# *Three*

# HERE, BUT CLEVERLY HIDDEN

Some pieces of Sioux Falls's storied past still exist, but might not be noticeable to the untrained eyes. This chapter highlights those pieces that are hidden, sometimes in plain sight. From Columbus College to Smitty's Pancake House, bits of Sioux Falls's past, thought lost, can be discovered. For example, evidence of the old trollies that used to rumble through the streets can still be seen downtown.

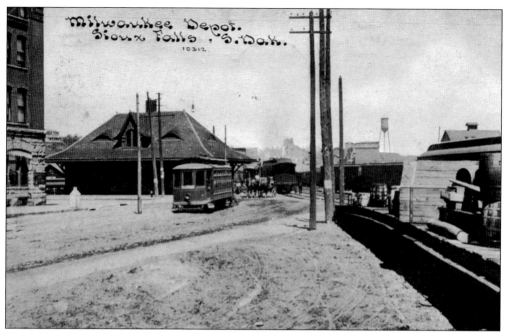

The Milwaukee depot, built in 1894 at Fifth Street and Phillips Avenue, received passengers from other parts of the area and the Sioux Falls Traction System took them to downtown hotels and all other parts of the city. The depot still stands today, but it is so completely transformed in appearance, one would hardly know it. At left is the Jewett Brothers wholesale grocery warehouse. Below, the building is seen as it stands now. Gone are the dramatic roof and eyebrow windows, the style that is said to have inspired Frank Lloyd Wright's prairie style. The building has been expanded considerably, but not following the style or materials of the original building.

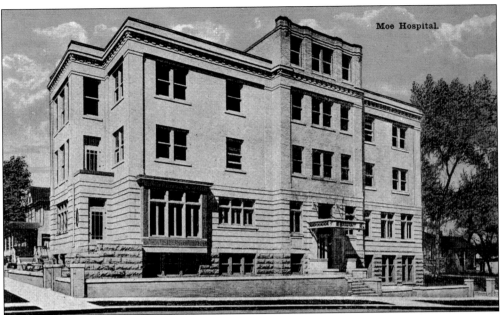

Moe Hospital.

Dr. Anton Moe was born in Trondheim, Norway, in 1868 and moved to the United States in 1883 with his family. He went to Rush Medical College in Chicago before moving to Heron Lake, Minnesota, to open Southwestern Minnesota Hosptial. In 1917, he opened Moe Hospital at the corner of Fourteenth Street and Main Avenue in Sioux Falls, which he ran until his death in 1939. The hospital closed after his death and the building was sold in 1941 to the National Reserve Life Insurance Company. It was purchased in 1958 by the legal firm of Davenport, Evans, Hurwitz, and Smith, which still occupies the space. There have been some changes to the building, but it is still recognizable today.

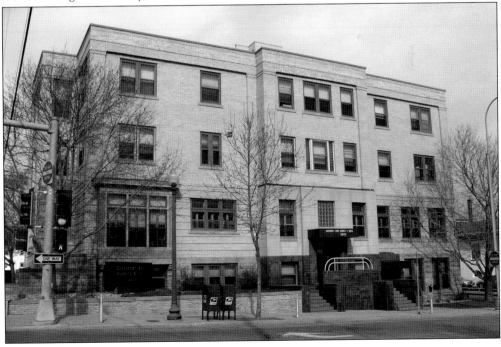

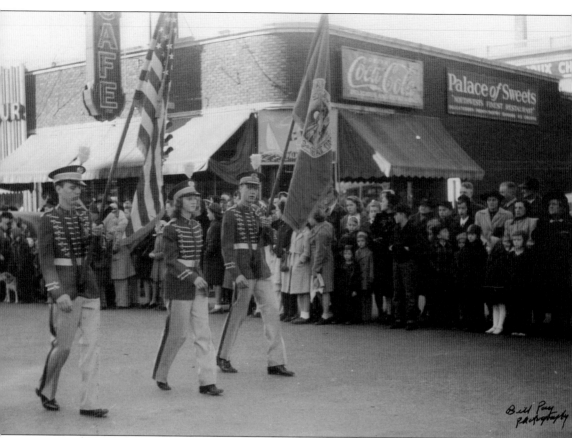

The mission statement of the Palace of Sweets states that it was organized in the spring of 1922 with a policy to respond to the public demands for quality food with a good variety of it. A variety of departments were put together to serve each particular need: fresh fruits and vegetables, a delicatessen, French pastries, candy, a soda fountain, and a cafe. The above image shows a 1941 parade of the Washington High School marching band passing in front. The business would remain the Palace of Sweets until 1948. Soon after, it would become Lemonds, named for the woman who formerly ran the tearoom at Shriver's. Lemonds served the downtown lunch crowd as well as the afterschool shoestring potato and malt crowd for years. Minerva's has been serving the public from this location since 1977. (Courtesy Bill Pay.)

The Sport Bowl opened just north of the Hollywood Theatre on Phillips Avenue in 1940. This building, also designed by Harold Spitznagel, was designed as a 16-lane bowling alley, bar, and restaurant in the moderne style. The street-level facade was covered in the curved porcelain panels that Spitznagel was so fond of, while the top consisted of overlapped aluminum panels featuring vertical grooves from which the building's neon letters seemed to emerge. Sport Bowl has long since moved to Burnside Avenue, and its old building is gone, but the style of the neon signage has followed it from its former home downtown, giving a suggestion of its roots. (Right, courtesy Bill Pay.)

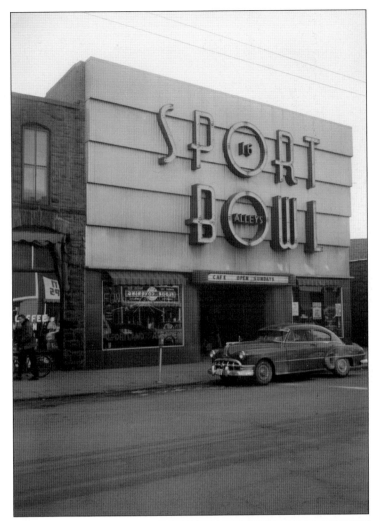

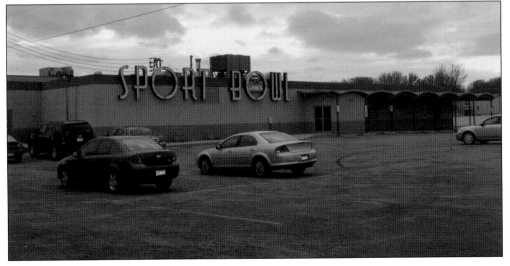

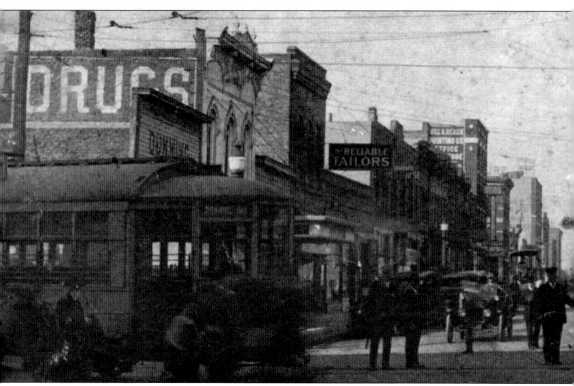

Richard Pettigrew and Samuel Tate were early providers of public transportation in Sioux Falls, starting in 1887 with their Sioux Falls Street Railroad. The car barn for the system was at Eleventh Street and Main Avenue and held three cars and four teams of horses. The most successful trolley system in town was the Sioux Falls Traction System (SFTS), shown here, which

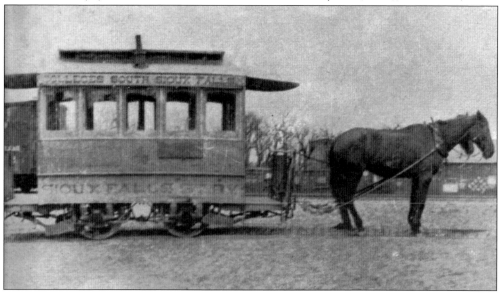

Pettigrew and Tate's Sioux Falls Street Railroad ran horse-drawn trolleys downtown, by all the major train depots and hotels, past the colleges, and up North West Street (now Burnside Street). (Courtesy Mark Helberg.)

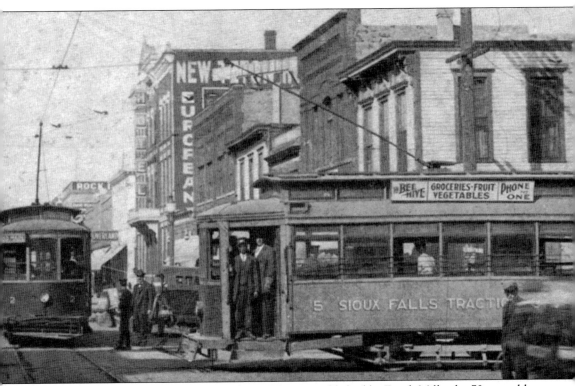

began operations on October 5, 1907. The SFTS was established by Frank Mills, the 70-year-old former owner of the *Des Moines Register*. This is Phillips Avenue at Eighth Street looking north. Presently, this view would show you the downtown Holiday Inn on the left side of the road. (Courtesy Mark Helberg.)

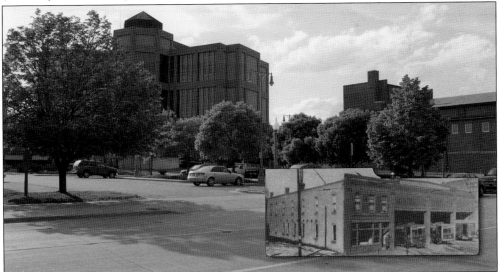

The SFTS's car barn, seen in the inset, was on Main Avenue, just north of the Minnehaha County Courthouse, which is now the old courthouse museum. It had room enough for 24 cars and office and storage room. It served as a home base for the trolley cars and a maintenance shed for the sick cars. It has since been removed and the space is now used for parking.

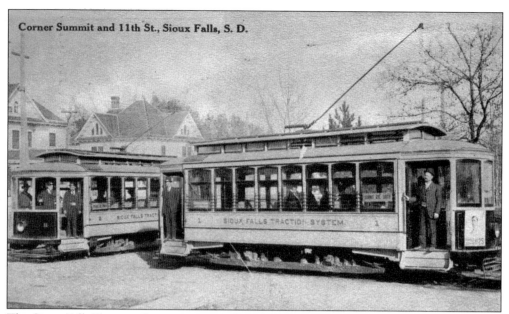

The Sioux Falls Traction System connected many parts of the city. Residents did not all have horses, so a trip downtown was more of a chore before Mills's transit system. Passengers could ride downtown to shop, to work at John Morrell's new meatpacking plant, or anywhere the trolleys went, for a nickel.

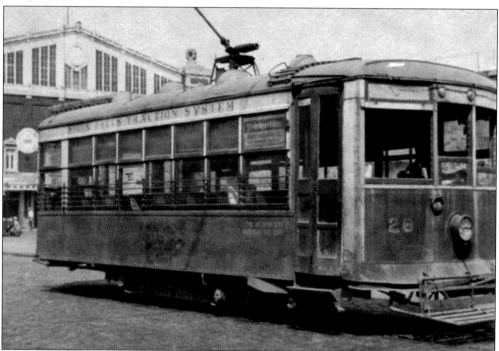

On August 28, 1929, shortly after 11:00 p.m., Car No. 28 pulled into the car barn south of the coliseum for the last time. The last fare was to Cannon's Hospital on the east side of town shortly after Frank Mills, the father of the Sioux Falls Traction System, died. The trolley lines could not compete with the emergence of the city bus. (Courtesy Mark Helberg.)

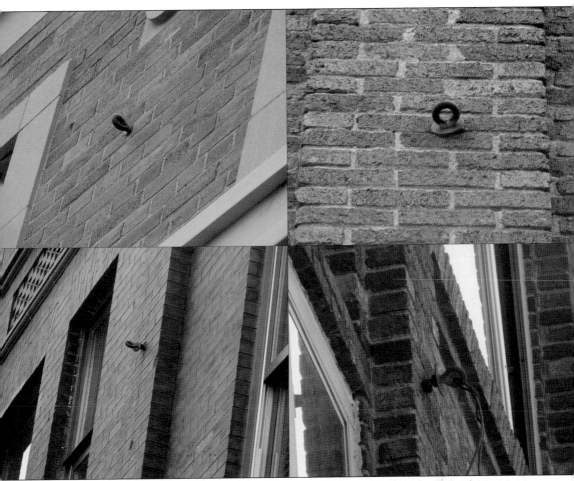

Mills's SFTS ceased operation in Sioux Falls, never to be seen again, but the keen observer can still see faint traces of this bygone transit system. The eyebolts that once held the electrical lines over Phillips Avenue can still be picked out on buildings from that time. These four were spotted on Shriver's Square and the Boyce Greeley and Beach-Pay buildings.

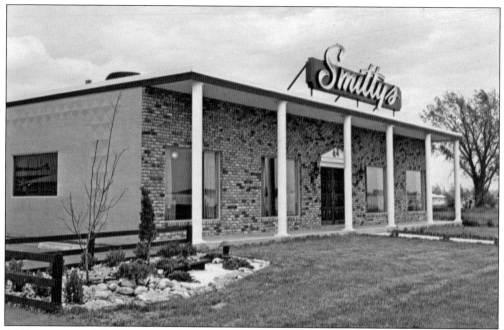

Al Kuper opened Smitty's Pancake House at Forty-first Street and Garfield Avenue in 1970. At the time, there was a lot more corn in the area than traffic. Kuper saw the potential of the recently opened Western Mall and knew traffic would steadily increase. Kuper had already owned a Smitty's on Indiana Avenue (now Phil's Pub) for two years, as well as the Harvey Rushmore Motel. For a time Smitty's Restaurants west of the Mississippi River operated under the Perkins umbrella, and in 1976, Kuper's pancake palaces, including his new location on West Forty-first Street, became Perkins. Kuper ran a friendly restaurant, which helped to keep both employees and customers coming back. His son, Steve Kuper, now owns and operates the first Forty-first Street location and business shows no sign of slowing down.

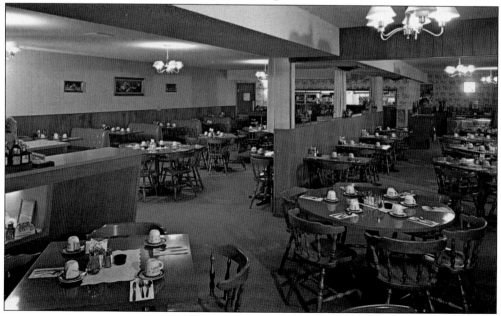

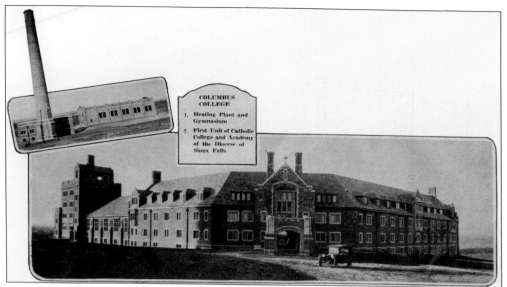

Columbus College opened in 1909 in Chamberlain, South Dakota, as a Catholic all-male prep school, high school, and college. It operated there for 12 years until Bishop Thomas O'Gorman lured the institution to Sioux Falls. In September 1921, the college reopened on 60 acres of land in Sioux Falls at 2501 West Twenty-second Street. Dormitories, classrooms, and other necessaries were built on campus in the Collegiate Gothic style seen here.

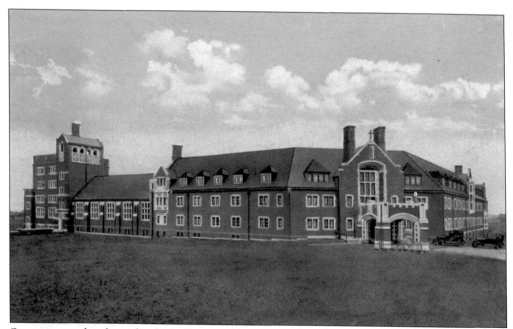

Sports were a big focus for the college, and Columbus College hoped to become another Notre Dame. The Columbus College Mariners dominated the South Dakota intercollegiate conference, even taking the 1926 league championship in football, basketball, and track.

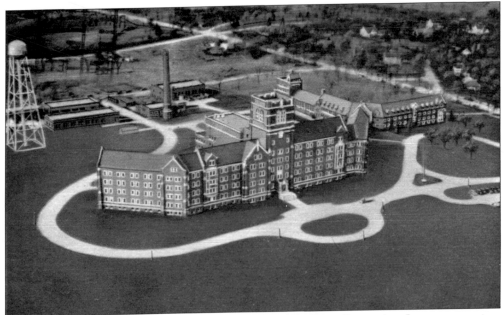

In 1929, Columbus College closed—an early casualty of the Great Depression. It spent some time in the 1930s as Columbus Orphanage and was purchased by the US government to be used as part of Veterans Memorial Hospital. The old Columbus College building is on the right. The north wing of the hospital feeds into it.

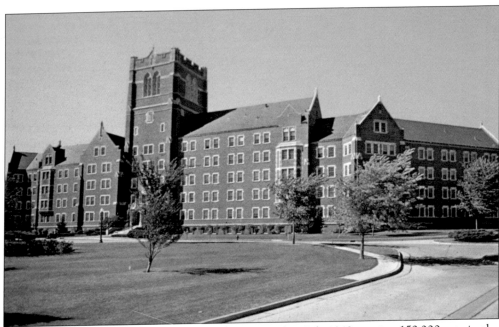

Royal C. Johnson Veterans Memorial Hospital opened in July 1949, serving 150,000 vets in the four-state area with 272 beds, costing the US government $5 million. Uncle Sam bought Columbus College during World War II and began building the main building, seen here in 1946, which still serves soldiers today.

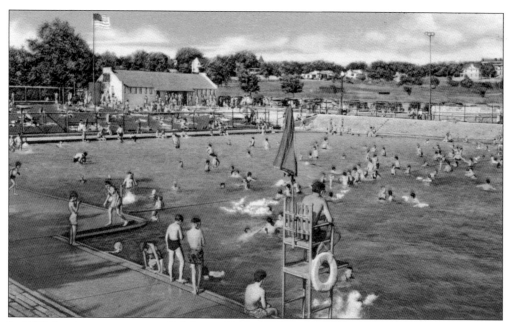

In 1888, local quarry magnate Col. James H. Drake discovered a natural spring on his land, near where Tenth Street and Cliff Avenue now intersect, and offered to supply the city with water. There were doubts as to whether Drake's spring could supply enough water for the growing city's needs, so the city declined. The city finally took him up on his offer in 1931 and purchased the land, but decided to use it for public recreation instead. The Drake Springs pool was completed in 1934. The sloping shores of the pool were originally concrete-lined with steps to produce an amphitheater effect. In 2008, work began on the Drake Springs Aquatic Family Center, just across the way from the original pool. The original pool is gone, but the spring still runs beneath it.

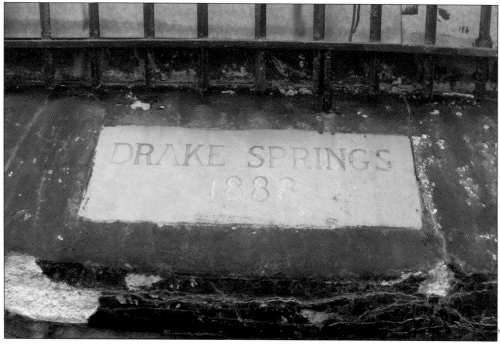

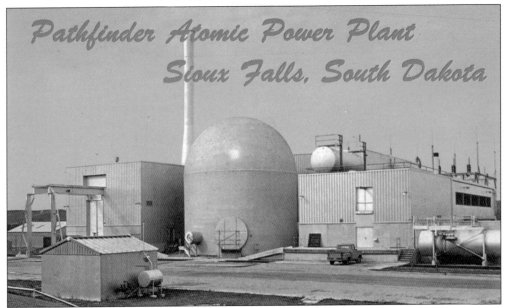

*Pathfinder Atomic Power Plant*
*Sioux Falls, South Dakota*

In July 1966, NSP opened the Pathfinder Nuclear Power Generating Station, the world's first all-nuclear generating station. It was named for Maj. Gen. John C. Fremont (1813–1890), who was nicknamed Pathfinder by the penny press. Pathfinder was quite a feather in our cap and local businesses played it up as a local attraction. The Pathfinder Nuclear Generating Station was run only briefly at peak output—about 30 minutes—before the plant was deemed incapable of safe operation. Pathfinder ceased operation in October 1967 and was converted to a gas- and coal-powered station. In 1990, the reactor vessel was removed and shipped away for safe disposal. In 1994, Pathfinder was renamed the Angus C. Anson Generating Plant to honor NSP's South Dakota division manager, who died in a plane crash with Gov. George Mickelson in 1993.

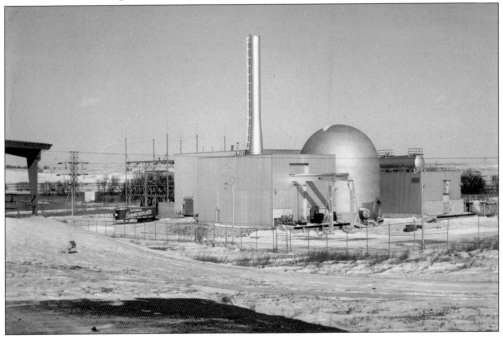

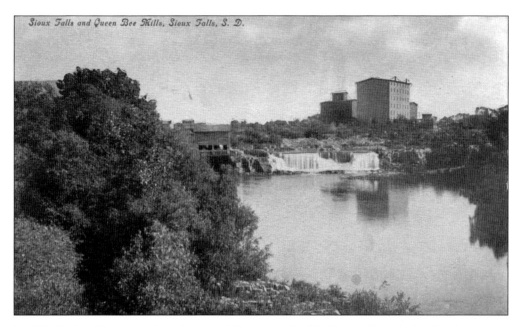

Sioux Falls and Queen Bee Mills, Sioux Falls, S. D.

In 1878, Richard Pettigrew thought it would be wise to build a flourmill on the banks of the Sioux River near the falls. He would harness the power of the falls to mill local wheat into flour and save farmers the trip to mills in Minnesota. The seven-story Queen Bee Mill was constructed with the help of New Jersey investor George Seney and opened in 1881. The mill closed in 1883, having overestimated the power of the falls and the amount of wheat in the area. Starting in 1929, the mill was used as a warehouse until a fire on January 30, 1956, took out the roof and floors. The walls were taken down in 1961 to prevent them from falling, but the ground floor walls of the Queen Bee Mill have been kept intact for posterity.

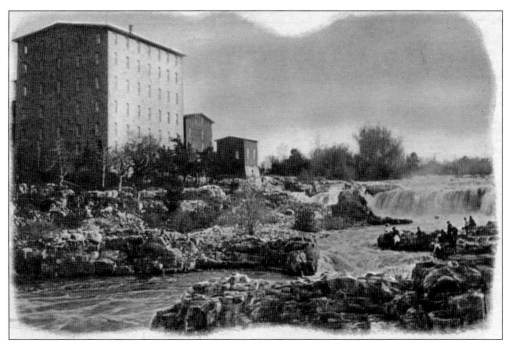

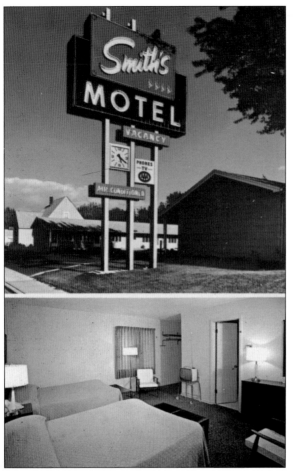

In 1938, Robert I. Smith quit his job at Morrell's to open Smith Cabin Camp, taking advantage of the nationwide craze of hitting the open road to discover America and its insects. He opened Smith's Cabins at the corner of Twelfth Street and Grange Avenue, a collection of tourist cabins one could rent like hotel rooms. It was not quite camping, but not quite a hotel stay. By 1958, Smith changed the name to Smith's Uptown Motel and replaced the cabins with long rows of rooms like a traditional motel. In 1989–1990, Smith's Motor Inn gave way to Nites Inn. Recently, apartment rentals have been offered, as well as weekly rates like the De Lux down the way.

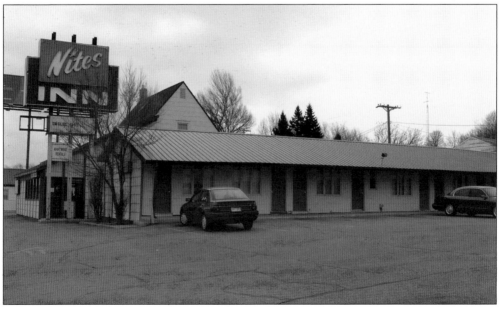

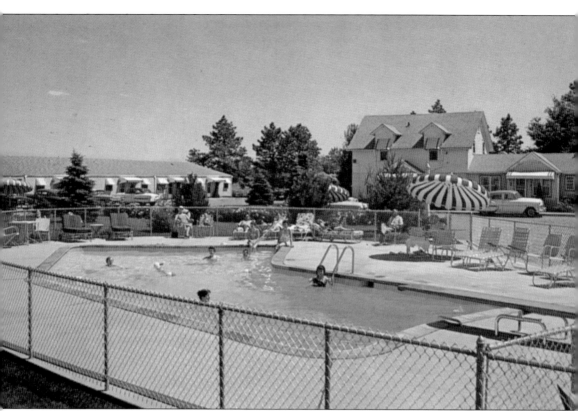

The Pine Crest Motel, at the corner of Twelfth Street and Interstate 29, has been around since the 1950s. It was equipped with 20 large one-, two-, and three-room units, air conditioning, radiant heat, two heated pools, and a playground for the kids. It has since been converted into efficiency apartments, and though the pools are gone, it looks much the same.

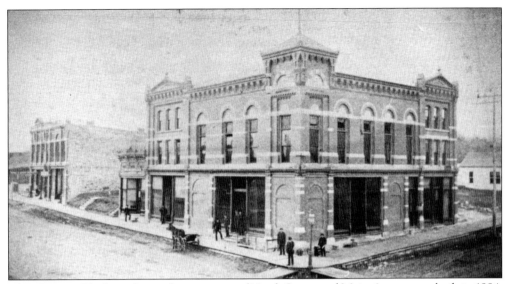

The Sherman Block on the southwest corner of Ninth Street and Main Avenue was built in 1884. Minnehaha National Bank first opened here in 1885. The post office was here before it moved to a new building in 1895, as were the county offices until 1890, when the Minnehaha County Courthouse was built. In 1898, the building was renovated and became the New Theatre. The building was razed in 1916. (Courtesy First National Bank.)

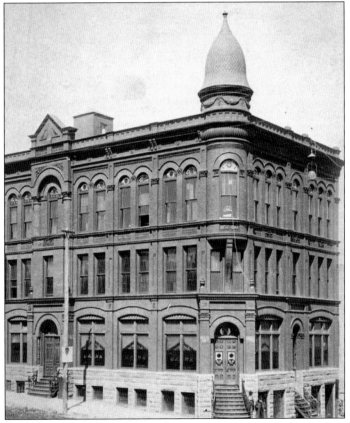

The Metropolitan Block, built in 1886 on the northwest corner of Ninth Street and Main Avenue, was the second home for Minnehaha National Bank (MNB), starting in 1887. Just across the street from its former location, the MNB used this location until moving to the Beach-Pay Block in 1898. The Metropolitan Block was torn down in 1965 at the beginning of urban renewal. (Courtesy First National Bank.)

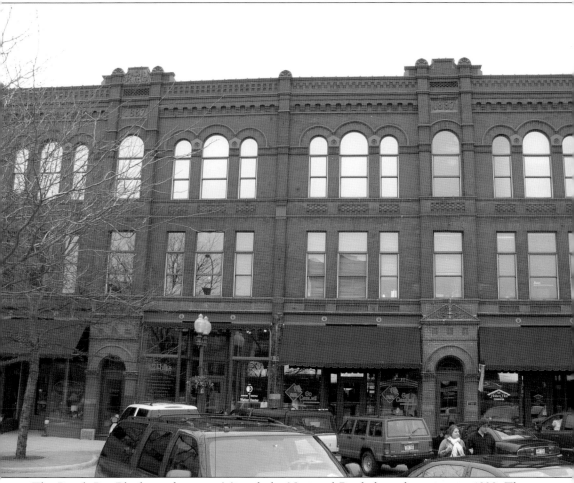

The Beach-Pay Block was home to Minnehaha National Bank for a short time in 1898. The building also housed Sioux Falls Business College. It was built in 1887 and still stands today, a fine example of an 1800s building still being put to good use.

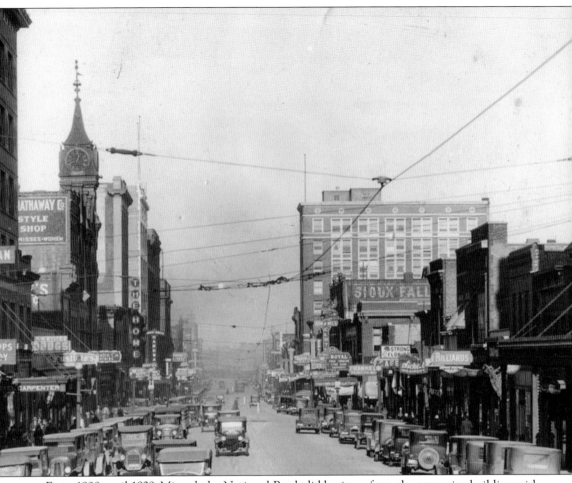

From 1898 until 1929, Minnehaha National Bank did business from the attractive building with the clock tower just left of center. The building was also used as a Masonic temple on the upper floors and S.S. Kresge started a five-and-dime here. The large building at the right is the Citizen's Bank Building, which was built in the early 1900s and still stands.

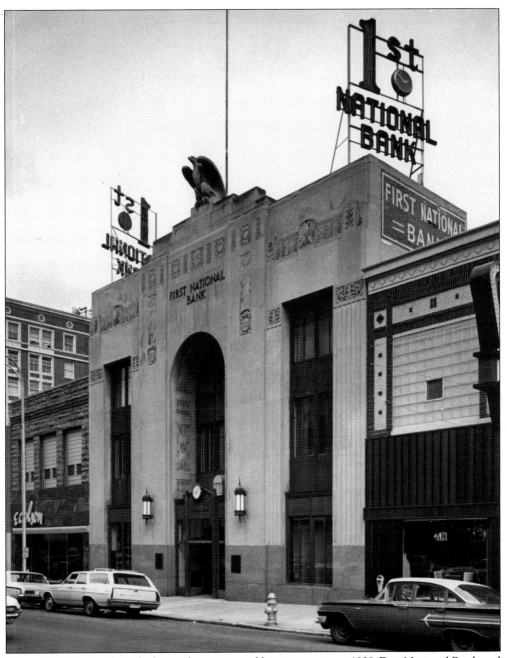

Minnehaha National Bank changed its name and location again in 1929. First National Bank and Trust Company was the new name and the company occupied this building, on Phillips Avenue just south of Ninth Street, until 1976. Note the majestic eagle atop the imposing structure and the neon signs on the roof. To the north was E.C. Olson clothiers, a popular shop for young men in the 1950s. (Courtesy First National Bank.)

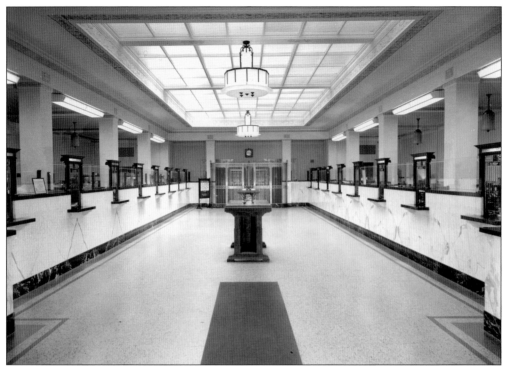

The interior of First National Bank is large, bright, and set up with 16 teller stations to serve customers. Toward the rear were the vault and safety deposit boxes. The building was torn down in 1976 after the new building went up just north of this location. (Courtesy First National Bank.)

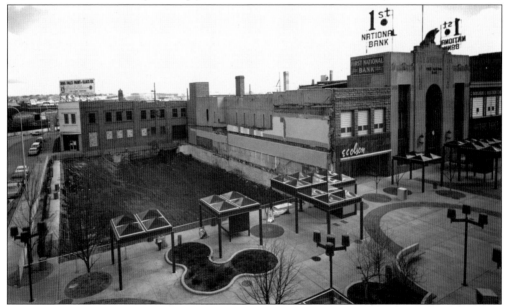

In 1974, construction began on the new building to the north. Perhaps more interesting in this image is the great shot of the walking mall installed on Phillips Avenue between Ninth and Eleventh Streets in 1973, created in order to draw shopping traffic from the Western Mall back to the old shopping district. It was taken out between 1986 and 1988. (Courtesy First National Bank.)

The majestic eagle from the former building was carefully removed from the top of the building and eventually placed on Phillips Avenue in front of the current bank. (Courtesy First National Bank.)

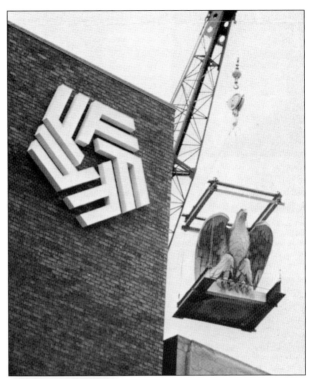

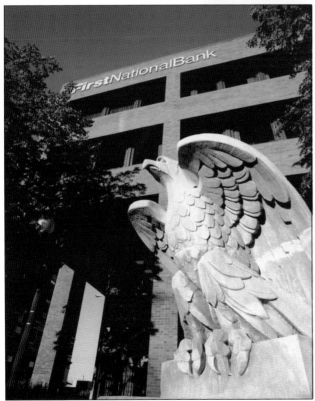

The great bird was cut across the middle at some point, but it does not detract from the majestic visage that seems to watch over the downtown sculpture walk every year. Not a bad mascot for a bank that has lasted 128 years in Sioux Falls. (Courtesy First National Bank.)

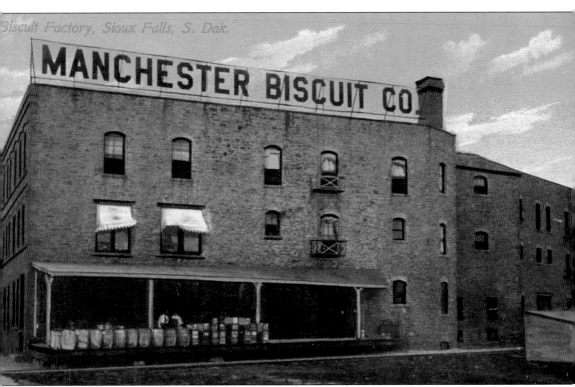

In 1902, local grocery wholesalers Andrew Kuehn and the Jewett brothers convinced L.D. Manchester to relocate his thriving biscuit concern to Sioux Falls from Luverne, Minnesota. As grocery wholesalers, they had a vested interest in bringing his wares into the fold. Manchester's first building was a two-story quartzite structure. The building seen here reveals a third story, which was added as the business grew.

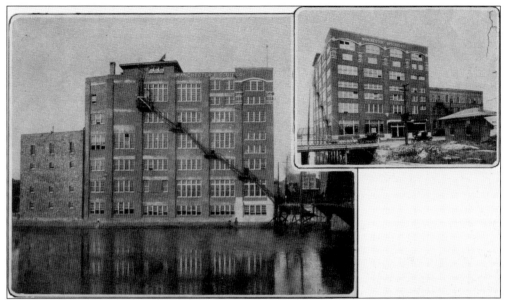

In 1915, local architect Joseph Schwarz designed this giant factory, which still stands today. The impressive edifice was equipped with the latest machinery, filling its almost three acres of floor space. By 1937, Manchester Biscuit Company had branches in Aberdeen, Rapid City, Sioux City, Omaha, and Lincoln, with a complete factory in Fargo.

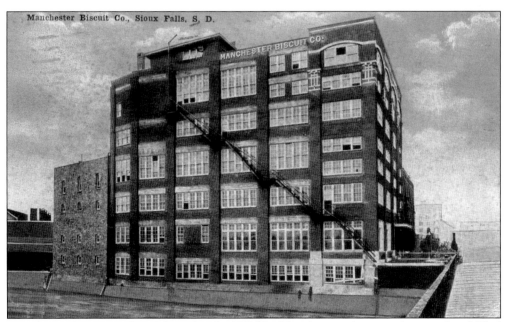

Manchester Biscuit produced daintily salted Waldorf Crackers, graham crackers, iced and filled wafers of many varieties, sugar wafers, and every other product known to the biscuit industry at the time. During the factory's life, visitors were admitted for free daily tours at 3:00 p.m.

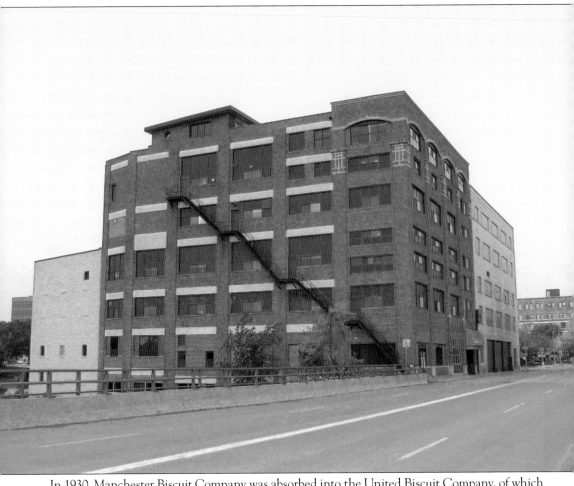

In 1930, Manchester Biscuit Company was absorbed into the United Biscuit Company, of which L.D. Manchester became president. He died a short time later. In 1960, United Biscuit ceased operation in Sioux Falls. Raven Industries purchased the building in 1961 and operates there to this day. In 1966, United Biscuit changed its name to Keebler.

# *Four*

# FUN TIDBITS

This last chapter is meant to share some unique perspectives on Sioux Falls. These images don't quite fit elsewhere, but still add flavor and character to this rich and wonderful city. The 1950s were a rich time for clever advertising, so some great examples of this have been included. There is also a collection of panoramas photographed in the early 1900s. They show how much the city has changed in the past century.

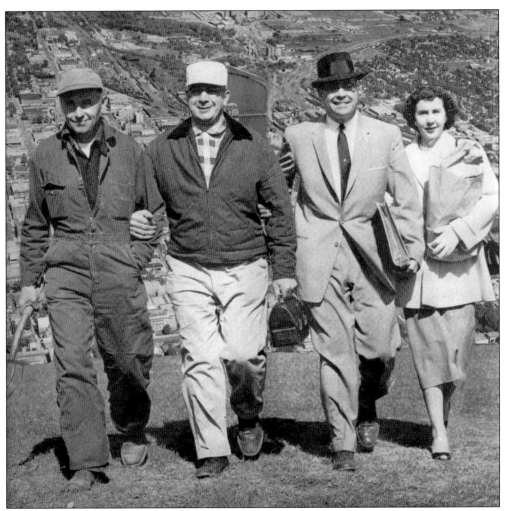

This amazing image is from a 1958 publication of the chamber of commerce called "Greater Sioux Falls." It is an inspirational piece showing people of all stripes walking lockstep toward a bright future on a hill apparently several hundred feet in the air toward the south side of town. There is no hill that offers this view in Sioux Falls, but the language of the piece is clear: "Sioux Falls—a city on the *grow*."

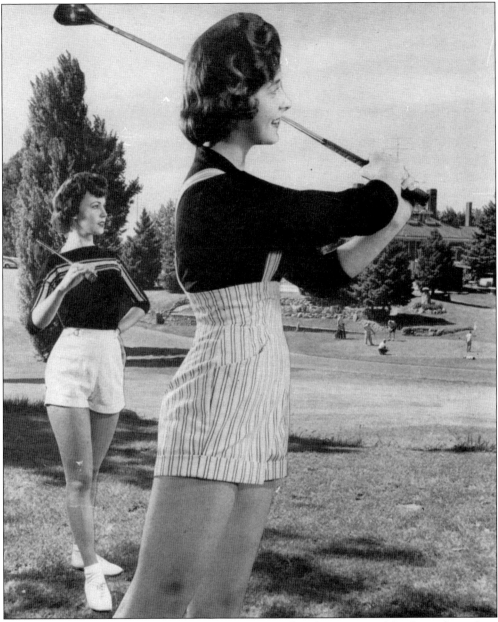

This image, also from the 1958 copy of "Greater Sioux Falls," shows two models, obviously cut from their original background—maybe a Sears catalog—and pasted over an image of the Minnehaha Country Club taken by Bill Pay two years earlier.

These two images were taken from a busy late 1950s map of Sioux Falls adorned with various facts and images designed to bring people to Sioux Falls for vacation, hunting, or perhaps a permanent move. The recurring heart image is part of the theme "heart of the great Sioux Empire" used throughout the map. It is unclear when the chamber of commerce coined the term "Sioux Empire," but the city still has two malls with names that reflect this: the Empire and the Empire East. The Sioux Emperor could not be reached for comment.

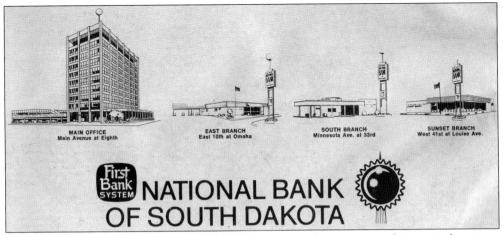

National Banks in Sioux Falls once had brilliant weather beacons atop their many locations. Since the late 1950s, these white, plastic balls with colored lights within would show a different color depending on the predicted temperature. A collection of verse to help decode the balls' predictions is below. (Courtesty Mark Helberg.)

When the Weatherball is red, warmer weather is ahead.
When the Weatherball is white, colder weather is in sight.
When the Weatherball is green, no change in weather is foreseen.
When colors blink by day or night, precipitation is in sight.

Not everyone remembers the same verse, and it is the kind of thing that may lead to blows if brought up in a bar. Only two of these fabled balls exist in Sioux Falls and they are no longer lit.

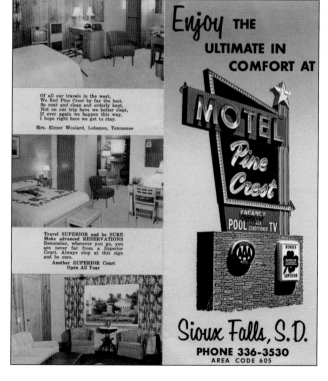

This is from a brochure put out by the Pine Crest Motel—or, as the sign suggests, "Motel Pine Crest"—in the early 1960s. According to the document, the Pine Crest was the kind of place that inspired its visitors to mail them poetry about their stay. It is hard to imagine franchise motels of today inspiring this kind of correspondence.

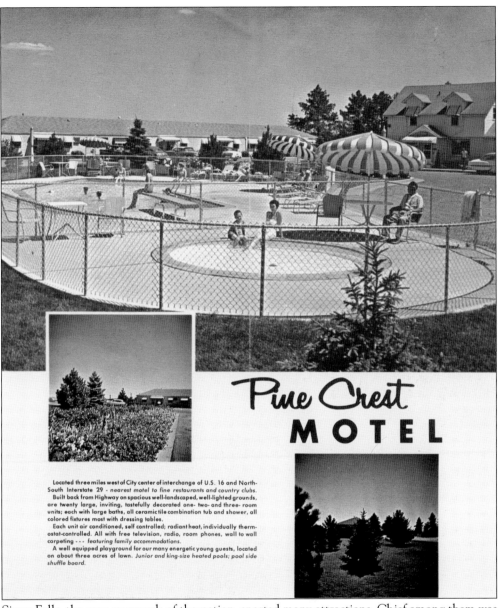

Located three miles west of City center of interchange of U.S. 16 and North-South Interstate 29 - nearest motel to fine restaurants and country clubs.

Built back from Highway on spacious well-landscaped, well-lighted grounds, are twenty large, inviting, tastefully decorated one- two- and three- room units; each with large baths, all ceramic tile combination tub and shower, all colored fixtures most with dressing tables.

Each unit air conditioned, self controlled; radiant heat, individually therm-ostat-controlled. All with free television, radio, room phones, wall to wall carpeting - - - featuring family accommodations.

A well equipped playground for our many energetic young guests, located on about three acres of lawn. Junior and king-size heated pools; pool side shuffle board.

Sioux Falls, the new crossroads of the nation, sported many attractions. Chief among them was the atomic power plant and West Sioux Hardware. Two of the finest "eating places" were supposed to be within a mile of the Pine Crest: Kirk's Cafe and the Town 'N Country. Both were fine examples of "greasy spoon" restaurants.

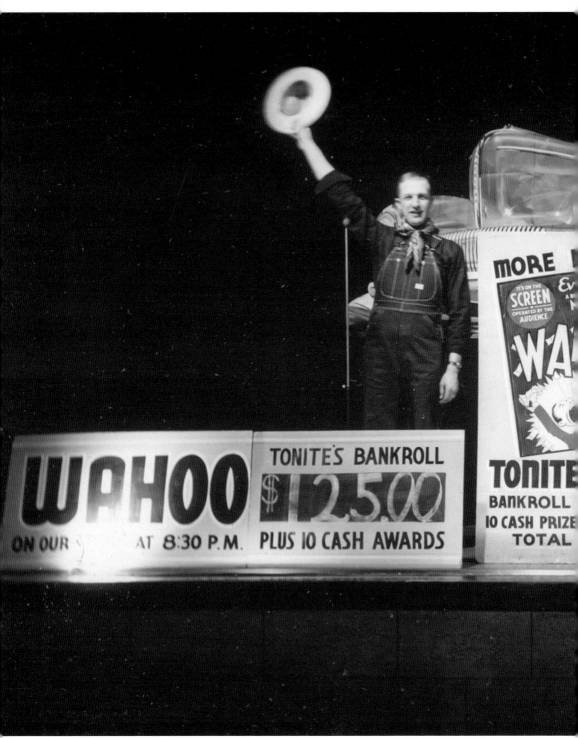

In the golden age of the cinema from the late 1920s to the early 1960s, theaters were very competitive, and each had its own gimmicks to fill the seats and sell more concessions. The Granada used the bingo-like game Wahoo! to add excitement to a night at the theater, with each patron being given

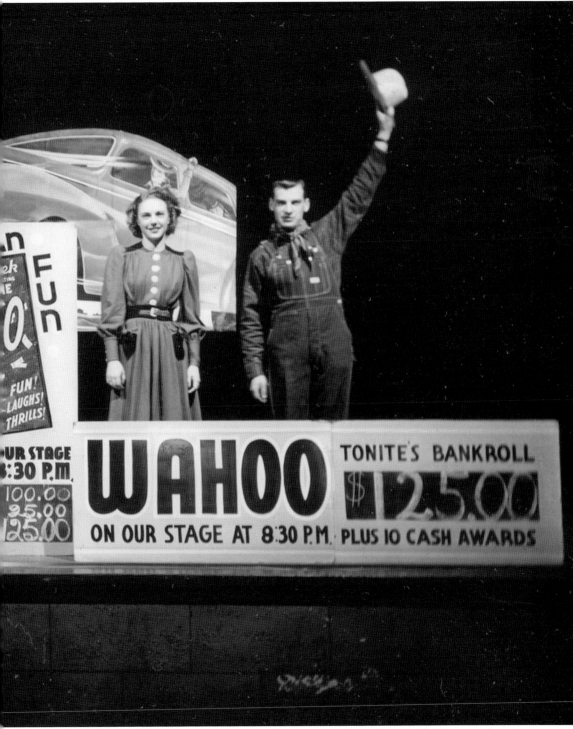

a Wahoo! card. On the stage here are Granada manager Helmer Rierson (left), an unidentified woman, and Don Rock. They may be doubling up Country Store Nite—another promotion—with Wahoo!, which would explain the overalls. (Courtesy Tom Johnson.)

# WAHOO!

TRADE MARK REG U S PAT OFF

Each time a number is called, punch out corresponding number on card. When you've punched (5) numbers in a row, either up or down, diagonally or straight across, shout "WAHOO"

| Nos. 1 to 15 | Nos. 16 to 30 | Nos. 31 to 45 | Nos. 46 to 60 | Nos. 61 to 75 |
|---|---|---|---|---|
| 15 | 20 | 33 | 47 | 67 |
| 4 | 26 | 42 | 59 | 72 |
| 13 | 27 | FREE | 56 | 75 |
| 9 | 18 | 39 | 48 | 68 |
| 14 | 30 | 32 | 50 | 71 |

110

Here is the Wahoo! game card. An on-screen spinner would indicate a number, which was punched out of the pre-perforated Wahoo! card by the theatergoer. When a lucky customer got five in a row,

# FREE!

## WED. AT 9 P.M.

## PLAY THE NEW SCREEN GAME

# WAHOO!

## FUN — LAUGHS — THRILLS

| | |
|---|---|
| BANK ROLL | $25.00 |
| 10 CASH AWARDS | $25.00 |
| TOTAL | $50.00 |

## FOR ENTERTAINMENT PURPOSES ONLY

## Always Ten Cash Awards

they would shout "Wahoo!" and hopefully bring home a cash prize. (Courtesy Tom Johnson.)

These unique images are of the State Theatre, but at angles not often enjoyed. The image above shows the balcony as viewed from within the organ chamber at stage left. Ordinarily, the organ chamber would be filled with the apparatus needed to fill the theater with music and silent film sound effects. At this point, this apparatus was in boxes and crates in the center of the auditorium, waiting for J.F. Nordlie's Pipe Organ Builders to give it the attention it needed. The image below is stage left, but in the wings of the stage. Above the stage, various backdrops can be seen that may have been used for the Vaudeville performances held at the State. On the stage is a speaker used to provide sound for a film from behind the silver screen.

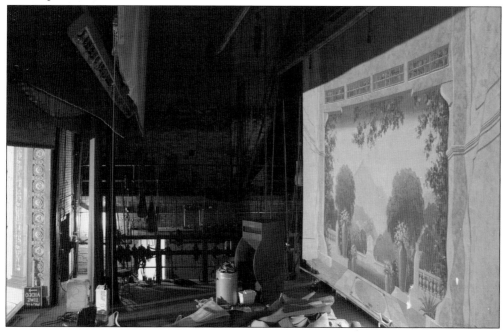

# Western Mall

## 2101 W. 41st Street, Sioux Falls

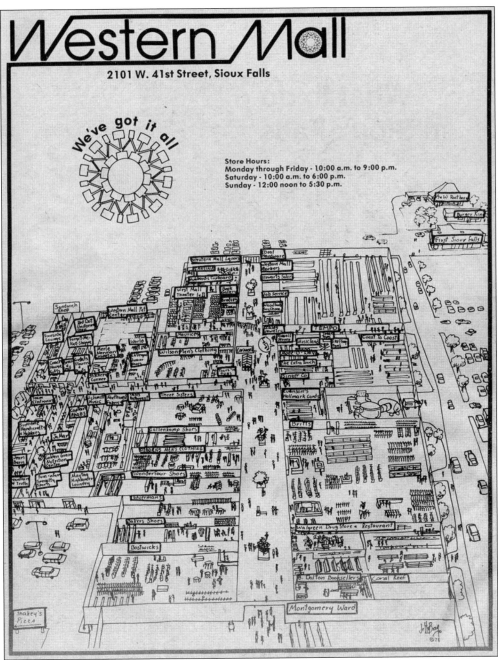

We've got it all

Store Hours:
Monday through Friday - 10:00 a.m. to 9:00 p.m.
Saturday - 10:00 a.m. to 6:00 p.m.
Sunday - 12:00 noon to 5:30 p.m.

In 1978, the *Argus Leader* printed this fascinating map of the Western Mall as it was at the time. Notice old stalwarts Montgomery Ward, Walgreens, Team Electronics, and B. Dalton. Seen also are less-well-known places such as Jean Barn, Captain Ahabs, and Ja Man. The Western Mall still thrives, but it is much different now, suffering from the same ailment that afflicts the Empire East—anchor stores with no adjoining conduit. The Western Mall currently has some very un-mall-like businesses within. Lawyers, school district offices, and Larry Hoover's SuperKarate, for example. While there is no KarmelKorn or Orange Julius, the West Mall 7 theaters still do a brisk business as a second run theater. (Courtesy Mark Helberg.)

Panoramic photography has been around for nearly as long as photography itself. It seems like it becomes more popular from time to time, then fades from favor for a bit. These panoramic photographs are from Sioux Falls in the early part of the 20th century. The shot above was taken from about Third Street and Dakota Avenue looking south. It is not clear what tall structure was there at the time to take the picture from. Toward the left of the shot is the Queen Bee Mill,

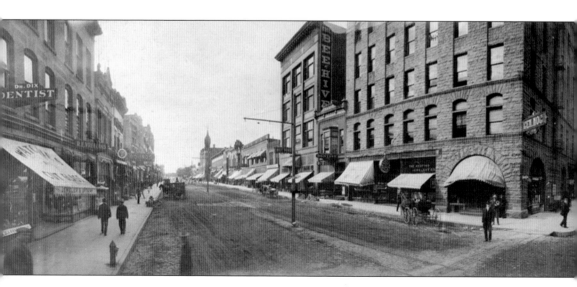

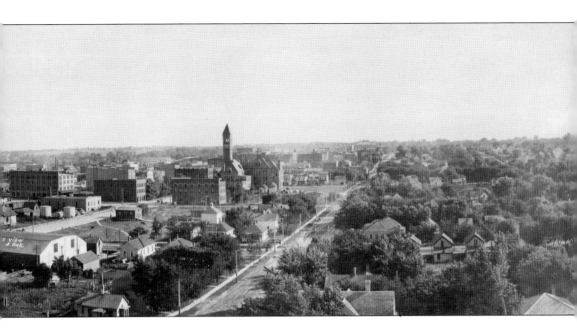

near the center is the Dakota Moline Plow Co., and to the right of center is the Minnehaha County Courthouse. The picture below shows the scene at Ninth Street and Phillips Avenue, the heart of Sioux Falls for many years. Some things of note are The Bee Hive department store left of center, the Minnehaha Building (also known as the Edmison & Jameson building), and the Cataract Hotel just right of center.

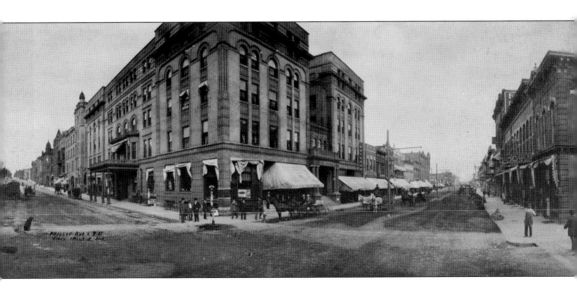

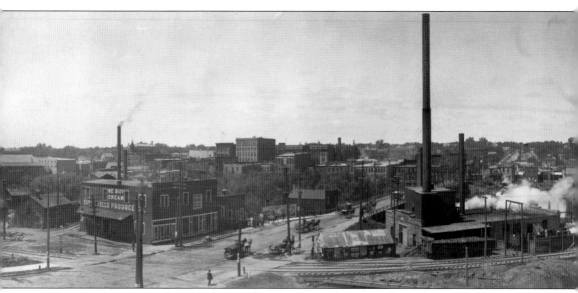

This 1908 panoramic photograph was taken from atop the Janesville Implement building east of the Illinois Central Depot in the 300 block of East Eighth Street. Points of interest include the

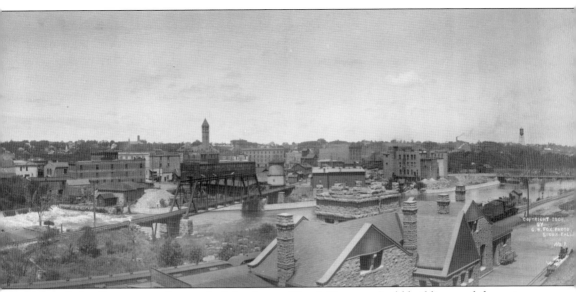

Minnehaha County courthouse, the Manchester Biscuit Company's old building, and the water tower that once stood on North Main Avenue in an area now known as Tower Park.

# DISCOVER THOUSANDS OF LOCAL HISTORY BOOKS
## FEATURING MILLIONS OF VINTAGE IMAGES

Arcadia Publishing, the leading local history publisher in the United States, is committed to making history accessible and meaningful through publishing books that celebrate and preserve the heritage of America's people and places.

Find more books like this at
## www.arcadiapublishing.com

Search for your hometown history, your old stomping grounds, and even your favorite sports team.